REFLECTIONS ON
BRITISH PAINTING

REFLECTIONS ON
BRITISH PAINTING

BY

ROGER FRY

Essay Index Reprint Series

BOOKS FOR LIBRARIES PRESS
FREEPORT, NEW YORK

First Published 1934
Reprinted 1969

STANDARD BOOK NUMBER:
8369-1350-7

LIBRARY OF CONGRESS CATALOG CARD NUMBER:
76-99695

PRINTED IN THE UNITED STATES OF AMERICA

ACKNOWLEDGMENT

I wish to express my gratitude to the various owners of pictures who have kindly permitted the reproduction of works in their collections.

ILLUSTRATIONS

7

ILLUSTRATIONS

ILLUSTRATIONS

9

ILLUSTRATIONS

ILLUSTRATIONS

ILLUSTRATIONS

ILLUSTRATIONS

ILLUSTRATIONS

14

ILLUSTRATIONS

PREFACE

In connection with the Exhibition of British Art at Burlington House in January of this year I delivered two lectures to the members of the National Art Collections Fund which form the substance of the following pages. Some abbreviations have been imposed by the impossibility of using as many illustrations as were available for the lectures, and elsewhere the matter has been slightly extended.

It could hardly be expected that such outspoken criticism as follows, of certain artists whose work has appealed to generations of Englishmen, would be received with general approval, and I cannot adequately express my admiration for the spirit of tolerance and open-mindedness which my audience displayed. This is, perhaps, one of the few countries where an art-critic is still free to lay impious hands on the idols of the tribe.

The spread on the Continent of an intolerance of free opinion, an intolerance which we used to think had passed with the Middle Ages, has given

us an enhanced sense of the value of our national distaste for coercion in matters of opinion. It should not be difficult to see how important that freedom of criticism is, even in this matter of our national artistic heritage. Some people were inclined to accuse me of taking that away from them. Nothing could be further from the truth. For the surest way to destroy that would be to suppress criticism. If once that could be done, the great names of our old masters would become mere symbols of national pride, mere flags and totems, and, as such—as the object of uncritical and therefore unintelligent worship—they would gradually cease to have any content and would in the end be forgotten. Each generation has to re-create the meaning of our old masters by critical appreciation : it is only by that means that they are kept alive. Indiscriminate worship would kill them.

But our concern must be as great for the future of British art. And here, no less than in keeping our heritage, free criticism may do the greatest service. If, for instance, we can discern in our past history causes which have been inimical to the full development of our natural aptitudes for art—and I believe them to be much greater than we are aware—it may help us to obviate them in the future.

I have tried in the following pages to suggest

some of these causes—sometimes due to a particular attitude to art in our social world, sometimes to imperfect understanding of the essentials of their art on the part of artists. But I should like in this context to insist on one which is peculiarly active just now: and that is 'snobbism', the tendency to believe in the value of right opinion—to think that by knowing whom one ought to admire, in order to pass as a man of taste, one achieves æsthetic salvation. Now right opinion—if there be such a thing—is by itself no better than wrong opinion. The only value of the opinion that Gainsborough is a great artist is in the quality of the experiences which are summed up in that statement. If it has been swallowed as a dogma, from no matter what authority, it has no significance. The great danger to art of the nineteenth century was Philistinism, an ignorant disinclination to recognize that the appreciation of great art requires more effort and attention than the effort to recognize the likeness of a painted figure to a real one. Its counterpart to-day is snobbism, the willingness to accept the dogmas of the *élite*. This too is a labour-saving device. And more serious even than its bad effect on the public is its effect on those artists it has canonized. When once an artist's name has been accepted by snobbism there is no further criticism of his work. It is all good because the name is right.

PREFACE

The greatest hope for art then lies in the growth of a vigorous, patiently appreciative, but sharply discriminating critical spirit among educated people. It is towards that that I strive, and I maintain that however wrong my judgments about the artists here discussed may be, my attempt to analyse my experiences before their works may be of some service in fostering that critical spirit.

REFLECTIONS ON BRITISH PAINTING

However valuable patriotism may be in certain fields of human activity, there are others from which it should be rigorously excluded. And assuredly one of those is art-history and the critical appreciation of works of art. Even the historian of his country's political development should endeavour to discount his patriotic bias, but we tend to judge his failure to do so with a certain leniency because his very subject-matter is so deeply tinged with patriotic feeling. But in the art-historian such a failure of detachment is far less excusable since the artist's allegiance is towards an ideal end which has nothing to do with the boundaries between nations.

Moreover, patriotic feeling, when it affects the art-historian, shows itself always at once futile and ridiculous. Some of you may remember the Exhibition of French Primitives in Paris nearly thirty years ago. One or two injudicious French writers took advantage of that occasion to attempt to prove a French origin for the art of the van Eycks,

and through them to lay claim to the glories of Flemish art. Alas! the stubbornness of facts proved their undoing, and no one to-day would deny that Belgium was a greater focus of pictorial art in the fifteenth century than France. And now to-day we can witness a similar attempt, but on a much grander scale and with more sublime disregard of evidence.

One of our greatest authorities on the art of early civilization was invited the other day to speak at an art-historical congress in Germany. In the invitation he was asked to bear in mind that the aim of the conference was to make known the fact that all the greatest art of the world had a Germanic origin. You must forgive this preamble, but I wanted to prepare you for the fact that I am not going to try to make out, what I believe would be an impossible case, though one which would give us all great satisfaction, namely, that Great Britain has been one of the great artistic centres of the world; that the British are by race and culture peculiarly gifted for creation in the visual arts.

For we know when we think of names like Giotto, Raphael, Titian, Rembrandt, Velazquez, that we are speaking of a class of artists to which no English painter can possibly be supposed to belong. Even when we think of Poussin, Watteau, Ingres, Degas, we could only suggest one or two names as comparable; while Spain, Holland and

Belgium have each one name that we cannot parallel. And in sculpture our position is even less satisfactory. If we were suddenly asked to mention a great English sculptor there is no name of sufficient resonance to rise instantly to our minds.

No, let us recognize straight away that ours is a minor school. But that does not mean that it is not intensely interesting, that it does not merit the most sympathetic and patient appreciation, that it has not its specific qualities, unlike those of all other schools, which it would be a great loss to miss or misunderstand. That, then, is the task which I have tried to fulfil, taking advantage of the great opportunity which the Exhibition at Burlington House offers to gain a wider and more general view of the whole field. I have, to the best of my abilities, brought to it a fresh and open mind, revising as well as I could any past impressions gained by narrower and more partial surveys.

First, then, let me rapidly survey the Exhibition as a whole, noting the more salient characteristics.

When I consider, then, the greatness of British civilization as a whole, its immense services to humanity in certain directions—in pure science and in political and economic thought—above all, when I consider its sublime achievements in literature—when I consider this magnificent record I have to admit sadly that British art is not altogether worthy of that civilization. Again and again,

as it seems to me, British artists have failed to re-
cognize the responsibilities of their calling; again
and again they have sacrificed to the demands of
their contemporary public what was meant for
posterity and mankind at large. There has been in
this country a low standard of artistic conscience.
We have nothing that corresponds to the moral
sublimity, the disinterested detachment of the
great French artists of the nineteenth century.
There has been among British artists a lack of that
spiritual torment, that anxious effort which in the
lives of the greatest artists forces them always to
wrestle with new problems, to probe more and
more deeply into the possible implications of the
visual world. There is among us a certain easy-
going complacency and indifference to the things
of the spirit which has attacked even some of our
most highly gifted artists and prevented them from
achieving all their latent possibilities.

I shall have to try to substantiate this later on,
but at the very outset one suspicious fact will have
been apparent to any visitor at Burlington House,
namely, the ominous preponderance of the por-
trait over all other kinds of picture, the absence of
any serious attempts at complicated constructions
in figure design combined with an almost total
absence of the nude figure, and almost equally
symptomatic, perhaps, the absence of still-life
paintings.

Now with regard to portraiture—no doubt some of the greatest works of art in the world are portraits, but they are very rarely the work of portrait painters. Raphael's two or three superb portraits were by-products of his far wider activities; Titian could never have painted his *Charles V* if he had not also done his great figure compositions; Rembrandt's greatest portraits were done when he had so far failed as a portrait painter that scarcely anyone would sit to him but himself. To cultivate the portrait exclusively or even mainly is a perilous thing for an artist, because it becomes almost part of his duty to sacrifice something of æsthetic necessities to non-æsthetic demands.

But this preponderance of the portrait in the British school gives us also a hint that we should be wrong to explain our shortcomings in the visual arts merely by blaming the artists. It is, we must suppose, rather some failure in our culture as a whole, whereby our governing classes, who alone have exercised patronage in the past, have been led to adopt a contemptuous and unimaginative attitude towards the visual arts—so that the typical English patron came to regard the artist merely in his capacity of ministering to his desire for prestige, by painting images of himself and

25

his family. He might, in the same way, call in the landscape painter to celebrate his ancestral home and its park—for topographical demands underlie our landscape as much as portraiture our figure art.

And why, you may wonder, do I regard the absence of still-life as so symptomatic? Well, the still-life is for post-Renaissance art a kind of acid test of the passion for disinterested and contemplative vision. It is the proof that the artist is so preoccupied with purely visual values that he can dispense with any other *raison d'être* for his picture.

And this consideration brings me straight to what I believe is the fundamental issue. It is the issue between a visual plastic art and a descriptive conceptual art. This may well seem to you to be a mere detail of technique out of which I am trying to make a fundamental principle. And if you should think thus you will have plenty of authorities to back you. For instance, Mr. Read, in a most interesting résumé of English art in the *Burlington Magazine* says:

'The technical quest that began with Giotto and Masaccio simply did not, and it might be said could not, enter into the plastic consciousness of an English artist.'

I feel here that we should amend 'plastic consciousness' to 'pictorial consciousness' since the

whole issue at stake is that of a plastic feeling in pictorial expression. Mr. Read must forgive me, too, if I here stress the words 'technical quest' unduly, but it helps to make clear my point, which is that this plastic consciousness is of prime importance in the spiritual value of visual art. For the power to see and feel plastic form is almost a measure of an artist's power to free himself from the interests of ordinary life and attain to an attitude of detachment in which the spiritual significance of formal relations become apparent.

Let us take the case of a man's head. In ordinary life our needs and interests compel us to pay great attention to the play of features, but there is nothing to induce us to look at the head as a whole, and, in consequence, very few people ever see such a thing. It is only when a man is strangely preoccupied with visual values that he takes in the form of a head as a whole. To do this demands, then, a more detached contemplative attitude to life.

But I would base my contention for the importance of plastic feeling in painting on the observed fact that, with the possible exception of Jan van Eyck, all the greatest masters of painting have used the central European idiom of painting which is based on a spatial and plastic imagination. That is why both the early

Flemish and the English schools are in the main provincial schools ignorant of the central European idiom.[1]

Now I do not mean to say that no British artists attain to plastic pictorial form, but rather that it does not seem to come to them easily or naturally. Their art is primarily linear, descriptive and non-plastic.

In the Gothic period England was known all over Europe for the beauty and perfection of its embroidery. So celebrated was this that it went by the name of *Opus Anglicanum*. Such English

[1] Anyone who is not familiar with this distinction can gain an idea of it by looking at Raphael's *St. Catherine* in the National Gallery and going from there to Jan van Eyck's portrait of *John Arnolfini and his Wife* in the Flemish room. When we look at the Raphael we are made so immediately and vividly aware of the whole bulk and volume of the body and of the head and of their relations to one another that we can in imagination feel all round the figure; we realize how the inclination of the surface at one point would change as we passed our hand over the figure.

Before the van Eyck, though we judge that solid three-dimensional forms are represented, we have no such vivid sense of their volume; we pass rather at once to the details of the features and of the dress and of all the objects in the room. Van Eyck describes shapes accurately, mainly by their limiting contours. In Raphael the sense of the shape is present to the mind throughout, and not merely at the boundaries.

embroidered copes are still treasured in various cathedrals all over the Continent.[1]

This was, of course, essentially an art of flat masses and marked outlines—its beauty depending on the patterns made by the contours, the quality of its texture and the delicacy and variety of the colour. It is, I think, of some significance that English art owed its early celebrity to this craft of flat embroidery.

In the thirteenth and fourteenth centuries England undoubtedly had a school of painting, though comparatively little remains of it. The altarpiece from Thornham Parva at the Exhibition is perhaps the most perfect example that survives. This, like the arts of miniature painting and glass work, was essentially linear.

But by the fifteenth century the English painters had no native style. They followed Flemish originals, for by this time the pre-eminence of Flemish painting in Northern Europe was completely established.

As I have said, Flemish painting was, compared

[1] It is only fair to state that the English sculptors of Nottingham also had a European reputation for their small reliefs of religious subjects like the *Stations of the Cross* in alabaster. But we must suppose that the chief attraction was the beauty of their material; for with a few exceptions these are so crude in modelling, so confused in design, that they bring to our minds the consoling thought that bad commercial art is not limited to our own age.

with that of Italy, essentially a flat descriptive art, but none the less its literal imitation of nature had led the Flemish artists to take note of changes in light and shade—to give some modelling and relief to their heads. But their English disciples were too much wedded to line to follow them in this. The portrait of *Margaret Beaufort* (*Fig. 1*) gives an example of this. Here the artist leans heavily on his linear contours and almost suppresses the modelling.

In the sixteenth century Holbein came to England, bringing with him a much more highly developed pictorial tradition with a much fuller sense of plastic relief. In the *Portrait of a Young Man* (*Fig. 3*), though there is very little light and shade, the treatment of the contour is such as to create a vivid sense of the volume of the figure and its situation in the picture space. Holbein himself was a supreme master of linear design; he could draw patterns for embroidery and jewellery as no one else, but he never entirely sacrificed the plastic feeling for form to that, and in his early work he modelled in full light and shade. Still, it was not difficult to him to adapt himself somewhat to the English fondness for flat linear pattern. Particularly in his royal portraits, e.g. Lord Spencer's

portrait of *Henry VIII*, we find an insistence on the details of the embroidered patterns of the clothes and the jewellery, which is out of key with the careful modelling of hands and face.[1]

Now, if we look at the English copy of Holbein's *Edward VI* in the National Portrait Gallery (*Fig. 4*), we find that the image is completely flattened out —it is reduced to the terms of the embroiderer's art with his delight in the patterned beauty of line.

Finally, by Elizabeth's reign almost all trace of Holbein's plastic feeling was swept away and the English instinct for linear description had triumphed completely. We know that the Queen herself insisted particularly that there should be no shadows on her face, though strangely enough she called this 'in the Italian manner'. At any rate in most Elizabethan portraits the embroidered dress is the real subject of the pictures (*Fig. 2*).

But the English were not left long in peace with their linear style. A king as cultured and art-loving as Charles I, one, too, who had travelled abroad, was bound to see that Rubens represented a much higher conception of art than anything we

[1] My own impression is that this peculiarity is the explanation of the heraldic flatness of the much-discussed Castle Howard portrait of *Henry VIII*.

possessed, and invited him over. He was followed
by van Dyck, who came to stay. And although he
too could not help feeling the influence of the bias
of English taste and learned to make his images
more flatly decorative and less powerfully modelled
than had been his wont, none the less, he set a new
standard of plastic design, and this was carried on
by Lely, whom we have decided, I think rightly, to
annex to the English school. Lely was not a great
artist, but he was thoroughly imbued with the prin-
ciples of three dimensional plastic design. Though
his portraits lack psychological subtlety and fail
to reveal clearly the sitter's individuality, they are
firmly and consistently constructed. In the por-
trait of *Nell Gwyn* (*Fig. 6*), for instance, the pose is
admirably felt, the movement is consistent and
harmonious throughout and we realize clearly the
relation of the figure to the space.

We tend to pass over Lely because he does not
interest us in the personality of his sitters, but from
the purely pictorial standpoint he stands high in
our art. I think he understood the principles of
design, and used them with an ease and assurance
that very few English painters of subsequent times
have equalled.

Kneller of the next generation carried on the
same tradition—and the portrait of the great
Sarah Duchess of Marlborough is very firmly de-
signed and modelled—you will find few por-

PLATE I

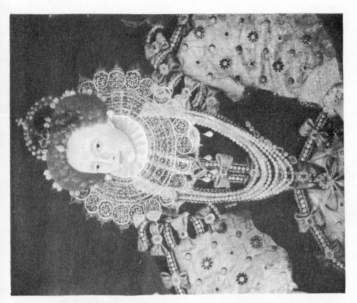

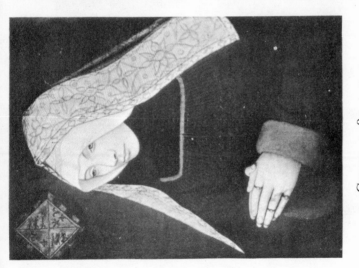

1. CIRCA 1485 A.D.:
The Lady Margaret Beaufort
National Portrait Gallery

2. ENGLISH SCHOOL: *Queen Elizabeth*
National Portrait Gallery

PLATE II

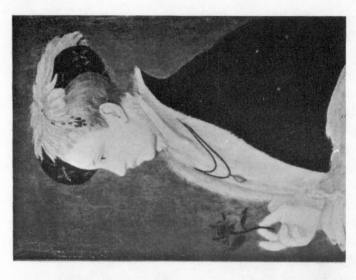

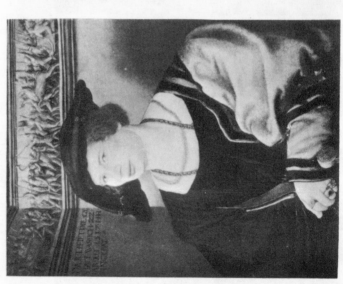

3. HOLBEIN : *Portrait*
Metropolitan Museum, New York

4. ENGLISH SCHOOL AFTER HOLBEIN :
Edward VI

traits at Burlington House in which the form is grasped as surely and easily as it is here.

An even better idea of the possibilities of English art at this moment can be gained by studying the portrait of *Lord Tweeddale* (*Fig. 7*) in the National Gallery. Here the head is frankly and powerfully modelled; the relief of the eye within its orbit is really masterly—it evinces at once mastery and precision. Most of the eighteenth-century painters were quite incapable of such grasp of form. They had to abandon precision to obtain breadth. This indeed is in the great tradition of painting.

Even so little known and often feeble an artist as Michael Wright shows that at moments he could construct coherently and with a sense of design in depth (*Fig. 5*).

English art, then, at the end of the seventeenth century seemed to have been drawn into the current of the European tradition; it had only to develop its own characteristic version of that.

But this period, I feel, marked a tragic crisis in the history of English art. It so happened that none of these men who had mastered the principles of plastic, pictorial design had any marked personality, much less genius. They were competent second-rate men with no definite imaginative attitude to life. If only the chances of heredity had thrown up one man of outstanding character; if only we had produced a Poussin, as France did, or

even a man of less power than he but of distinctive and imposing character, our art might have retained and developed this great tradition.

In architecture we did indeed have this good fortune. In Wren we did produce, as it seems to me, the greatest artistic personality of our nation —a man that one can put beside the great Italians and perhaps above any of the French. And his effect is seen in the noble and consistent tradition of most of our eighteenth-century architecture. But in painting our good fortune failed us, so that we have no painting at all worthy to be put beside that culminating expression of English taste and feeling in design which marks the end of the seventeenth and the early decades of the eighteenth century.

For that grand period when nearly all our architecture and applied art showed supreme distinction and a quite specifically English tact and delicacy of taste—for that period, I say, we have nothing in painting better than Hogarth.

And is that not enough? you will perhaps ask. I think not. I do not think that English society had, at that moment, the painter it deserved and that it would have known how to appreciate and value. The trouble lay, I think, in Hogarth's char-

acter. He was essentially what the French so conveniently call *primaire*, i.e. a man whose limited and reach-me-down culture gives him a ready answer to any problem, who becomes dogmatic, narrow-minded, positive and self-satisfied. The English aristocracy of the period had a very genuine interest in the fine arts and in literature. They were exercising enlightened patronage in the architecture and fittings of their country houses, and were deeply interested in the old masters. Hogarth, with his superficial common sense, his fundamental Philistinism, saw nothing but affectation in this and denounced it with his accustomed vehemence. Turning his back on the cultured world, he made an appeal, through his engravings, to a less sophisticated public. But he saw that the only art that would attract them must tell a story with rather crude insistence, and thus he turned almost entirely to illustration.

I think this may perhaps explain what strikes one as strangely paradoxical in Hogarth's work. For his special quality as an artist, his authentic gift seems to be in flat contradiction to his work as an illustrator. As an illustrator he seems to me crude, over-emphatic and heavy-handed, without any of the sharp psychological insight which might give his work value.

Whereas, as a pure painter his most marked character is a delicate, silvery tonality, with a peculiar

fugitive, vaporous quality as of a clumsy but more discreet Fragonard. The *Staymaker* (*Fig. 10*), for instance, is almost Whistlerian in its vaporous evanescent quality—its mere hints and suggestions of form: and the colour is, if anything, over-subtle and restrained. In the best of his finished pictures—in some of the *Marriage à la Mode*—something of this beauty and delicacy of tone survives. But the necessities of story-telling too often obscure this by reason of Hogarth's overcharged detail. We must go then to his sketches to realize Hogarth's finer qualities. In the well-known *Shrimp Girl* of the National Gallery there is a delightful freshness and spontaneity of touch. Hogarth's drawings show how superficial his sense of form was, but such first indications of the general form as he there lays in with a flowing brush are very felicitous.

For Hogarth was a born painter in the strict and limited sense of the word; he had the art of a vigorous direct statement and a feeling for the density and richness of his material. He had a painter's sensual feeling for the material texture. Moreover, without being a great colourist he had easy command of the harmonies which distinguish the Queen Anne period—those tender and rather muted harmonies which survive in the stuffs and painted objects of art of the period—harmonies based on warm greens, browns, dull yellows and faded rose.

PLATE III

6. SIR PETER LELY : *Nell Gwyn*
National Portrait Gallery

5. MICHAEL WRIGHT : *Thomas Chiffinch*
National Portrait Gallery

PLATE IV

8. WILLIAM HOGARTH : *Ann Hogarth*

7. SIR GODFREY KNELLER : *The Marquis of Tweeddale*

These gifts were quite sufficient to give great charm to such portraits as the *Mrs. Salter* which is in the National Gallery. It is true that there is not much character in the head—his contemporaries complained of this want in him—but it is extremely pleasant in tone and colour and in the fat, buttery quality of his pigment.

The face is well modelled, though, as usual with him, the eyes are out of tone and do not stay in their place. But the construction of the figure is by no means firm. Hogarth puts us off here with the pleasant and crisp handling of his flounces, but fails to convey any certain grasp of the underlying form. This lacks the vigorous construction of Kneller's *Duchess of Marlborough*.

In his portrait of *The Garricks* at Windsor Hogarth did achieve a fairly successful design of two figures, not without a certain effort towards a feeling for recession and depth, although even more there the uncertainty of his grasp of plastic form is apparent.

In all his work the drawing is lacking in sensitiveness. He defines his shapes in full, rounded curves which repeat themselves monotonously throughout. It was an easy and effective convention for form which tended to become a commonplace of eighteenth-century drawing. We find it further exaggerated in the roly-poly handwriting of Rowlandson. No one with a passionate interest in form could have been contented with it. But

when we have made all reservations, such pictures as these merit our admiration for their solid painter-like quality.

But Hogarth's pictorial feeling, sound enough when he dealt with a single volume, was utterly at fault when it came to the treatment of a group of figures and their relation to the picture space.

Thus, in the picture of *Lord George Graham in his Cabin*, whilst each figure is fairly solid and well understood, they are grouped with an extraordinary want of feeling for formal relations. The figures are simply strung out across the canvas as though Hogarth were making a catalogue. And as though that were not bad enough, he actually makes the intervals almost exactly equal. The most elementary understanding of composition would have prevented such a proceeding.

Here we have to get what pleasure we can from the illustration. And that certainly has a certain charm, for here Hogarth, having no satirical intention, conveys to us a certain humorous enjoyment of the quaintness of the scene and the oddities of the persons.

But when Hogarth is on his moral high horse, castigating the vices and follies of mankind, this humorous quality disappears. His attitude is too one-sided and too predetermined for him to see deeply into character. Perhaps the gesture of the lady in ecstasy over the beauty of a piece of china

in *Taste in High Life* (*Fig. 9*) is almost as well hit off as any, but the man is too merely a puppet to make it interesting what he is or does. This seems to show also that in such pictures Hogarth has no interest whatever in his design. He merely puts down his personages as they occur to his mind without regard to their relations in the design. There is no organization, no combination into larger groups. Here, for instance, only an extreme insensitiveness to such relations would have tolerated the sharp, cutting, narrow triangle left between the maid's and her mistress's dresses. Hogarth was too much amused by inventing the elaborate and rather grossly comic symbolism which you can decipher in the background to pay attention to such things.

Even in what is regarded by some of Hogarth's admirers as his masterpiece, *The Levée* in *The Rake's Progress* (*Fig. 11*) in the Soane Museum, we find nearly as much indifference to formal relations. For here, too, the figures succeed one another across the stage at almost equal intervals; there is no attempt to build up bigger units by grouping and organization—each figure is seen separately. In short, there is no focus of vision. And again in the light and shade there is no attempt to modulate the accent. It falls equally on all the actors in the foreground. Nor does this seem to me to show any profound psychological insight. The dancing master

and the dun are both crudely exaggerated types. Only perhaps in the vacuous good nature of the Rake himself does Hogarth get a little deeper.

In relation to this it may be of interest to remind you of what Pope said of Hogarth:

'How I want thee, humorous Hogarth!
Thou, I hear, a pleasant rogue art.
Were but you and I acquainted,
Every monster should be painted.
You should try your graving tools
On this odious group of fools;
Draw the beasts as I describe them;
Form their features while I gibe them;
Draw them like, for I assure ye
You will need no car'catura;
Draw them so that we may trace
All the Soul in every face.' [1]

That, however, is what Hogarth could not do. He lacked altogether the detachment and fineness of observation for that. He had nothing of the subtlety of true comedic painting such as we find in Rembrandt, Ter Borch and Chardin. He was a propagandist for morals, and the propagandist never even wants to discover the truth; he is in too great a hurry to make his case against the fools and

[1] Churchill's well-known lines throw a different light on the value of Hogarth's company:

'Oft have I known thee, Hogarth, weak and vain,
Thyself the idol of thy awkward strain,
Through the dull measure of a summer's day,
In phrase most vile, prate long, long hours away,
Whilst friends with friends all gaping sit, and gaze
To hear a Hogarth babble Hogarth's praise.'

the wicked, having, as a rule, no idea how like the fools and the wicked are to the wise and good. Hogarth's weapon is heavy caricature and also an elaborate symbolism which is ingenious enough and sometimes amusing in its grossness.

Hogarth is said to have been influenced by Jan Steen (*Fig. 12*). It is a thousand pities that he did not study him with a little more intelligence. He might then have learnt that it was possible to do a comedy of life and at the same time create a beautiful and consistent design. The comparison shows you at once how much is gained by organizing the groups, by uniting them together by leading lines, and by an imaginative grasp of the spatial relations of the volumes. Compared with the consummate pictorial science of this, Hogarth's compositions are puerile. Jan Steen, of course, is also interested in the psychological aspect of life, but his comedy is far more telling in that he shows no *parti pris*. This is much nearer to Pope's ideal of showing the soul in every face.

One could not expect of a man like Hogarth that he should see that the moral virtues of sincerity and persistency, necessary to produce a good picture, even if it is only a still-life, are rarer and more valuable, in the long run, than those required to damn the sins one is not inclined to.

In fact one cannot help wishing that he had paid more attention to cultivating his own very genuine

gifts as a painter and less to improving other people. For I think his influence on British art has been bad upon the whole. It has tended to sanction a disparagement of painting as a pure art—has tended to make artists think that they must justify themselves by conveying valuable, or important, or moral ideas. Watts in the later nineteenth century afforded a pathetic illustration of this tendency —nor has it ceased to operate to-day. It has obscured the truth that art has its own specific function, that it conveys experiences which are *sui generis*, not to be defined or valued by anything outside—experiences which have immense, but quite inexplicable, value to those who are sensitive to them—experiences closely analogous to those conveyed by music.

Whilst we are on the subject of illustration let us turn to Zoffany, a very much smaller personality than Hogarth and less gifted by nature, but fortunately not obsessed by any idea of the importance of his message to mankind. As a result, his pictures give us a delightful insight into eighteenth-century life. Zoffany has no axe to grind, no thesis to prove. He just looked at the spectacle of the life around him with naïve, uncritical enjoyment and recorded his feeling in a simple, straightforward,

unaffected manner. Even though he has no psychological acumen, simply because he has no *parti pris*, he brings us into easy contact with that vanished world.

The picture of *The Garricks entertaining Dr. Johnson on the lawn of their villa (Fig. 14)* is a charming little comedy of manners of the time, and Zoffany has such a childlike enjoyment in everything, he is so genially humorous about the people, so pleased by the tranquillity of the landscape, that the picture has something of the air of a primitive painting—it reminds one of the shepherds and meadows of a Foucquet miniature or some predella picture by Paolo di Giovanni.

Zoffany never aimed very high: he was contented with a simple prose style—but he never lets us down, and in *The Clandestine Marriage*, a scene from the contemporary stage, he achieved a minor masterpiece with its rich, firm pigment and luminous colouring.

Returning now to chronological order—the next considerable painter after Hogarth was Richard Wilson. His early portrait and figure painting is curious and not unpleasant, but so wooden in touch that one cannot wonder that he abandoned it for landscape.

All through the eighteenth century the land-
scapes of Claude enjoyed a great popularity with
the cultured aristocracy of England, which
accounts for so many of his masterpieces being
still in this country. Young noblemen who made
the grand tour brought back with them memories
of the luminous tranquillity, the Virgilian suavity
of Italian landscape, and it was through Claude's
pictures and the Palladian country houses which
they built, that they sought to recapture the poetry
and romance of their youth. Even when the
Gothic had begun to give a new direction to
romantic day-dreaming, they did not altogether
abandon their love for Italy, and we find in
Turner how curiously the two feelings could be
blended together. No wonder, then, that certain
artists shared in feelings which were so marked a
characteristic of English sentiment of the day.
Now this feeling was essentially bound up with
poetical allusions and reminiscences, and it was
towards the evocation of these feelings that the
artists naturally strove. So they went to Claude
and Poussin almost exclusively for that quality in
their work, for the overtones of their vision rather
than for the vision itself. They tried to skim off
from their design just these poetic evocations with-
out attempting to construct a landscape as they
had. Wilson is the great type of this *genre*, and in
his study of the classic landscape painters he made

PLATE V

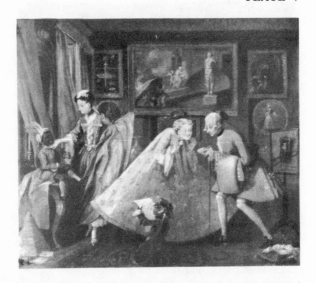

9. WILLIAM HOGARTH: *Taste in High Life*
Lord Iveagh Collection

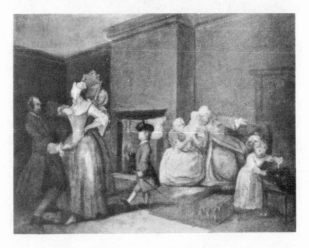

10. WILLIAM HOGARTH: *The Staymaker*
Sir Edmund Davis Collection

PLATE VI

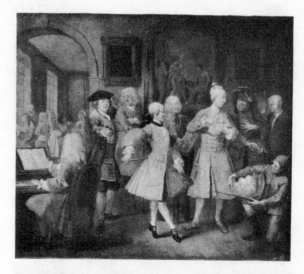

11. WILLIAM HOGARTH : *The Rake's Levee*
Sir John Soane Museum. By Permission of the Trustees

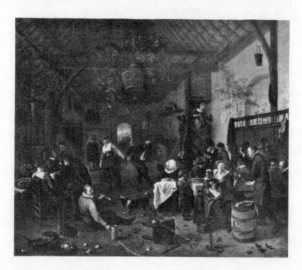

12. JAN STEEN : *Carousal*
Royal Collection, Buckingham Palace
By Gracious Permission of His Majesty The King

the same kind of mistake as we shall see Reynolds did later on—the mistake of thinking that you can imitate a final result without understanding the underlying processes.

In some of Wilson's pictures you will find as many picturesque moments as would have sufficed Poussin for several compositions, all brought together in a single design. But thus they become too effective, too picturesque, and in between, the design tends to break down and become insignificant, as though the artist had nothing definite to say.

This it is, I think, that prevents Wilson from being more than a very sympathetic minor figure —a painter whom one would like to admire more whole-heartedly than one can. His landscapes proclaim at once their classic calm, their mood of tranquil reverie; we are attracted at once by their wide spaces of sky, their distant sunlit clouds and the deep shade of their trees, but, alas! they do not hold up to their promise, and gradually as their emptiness of content, their merely scenic quality, make themselves felt the charm evaporates. They will not bear prolonged contemplation. One dreads to find out too clearly how the trick is done.

It is just the other way with Claude himself; what at first strikes one as an almost theatrical illusion becomes more and more real as you look —those vaporous distances gradually reveal all the

movements of the terrain; that sky ceases to be a
flat slab of rather dull paint and becomes an en-
folding dome of luminous air; and even those
rather absurd temples stand free and solid in the
luminous space, whilst, alas, Wilson's receding dis-
tances resolve themselves into a succession of flat
side-scenes placed one behind another. His skies—
although a luscious pigment replaces Claude's
hard dullness of surface—have no depth; there is
no structure anywhere; there is no real continuity
in the transitions from one plane to another. He
thinks in terms of silhouettes, not of mass and
volume. I am sure that Wilson had a genuine
poetical feeling for landscape, but he tried to get at
his poetry straight away; he could not wait to let it
distil from his forms, or rather he never was inter-
ested in the forms, as such. He never penetrated
through the general vague impression to what
underlies it.

No doubt that vague general feeling for the
poetry of a scene was genuine, and that he was
always open to receive it from nature. Often, it is
true, before a natural scene he seems to have at the
back of his mind the kind of picture by Claude or
Poussin that will, as it were, go bail for nature, will
authorize and justify the picture to be made from it,
but in his *Tabley House* at Burlington House, he was
face to face with nature—no Claude gave him
authority; the motive is all his own. He has felt

directly the charm of this wide-spreading lawn, bathed in afternoon sunlight and the water and the little clump of trees. But he had not the feeling for interval which would have given it its full significance; nothing here seems to belong inevitably to its place—it is all a little casual and uncertain. It is just such a theme as Seurat with his passion for space might have treated; but if he had, we should have felt at once that every interval was inevitable, every transition unalterably right.[1] Nor is there here any full realization of the receding plane; we know by the perspective what distance separates us from the house to the left, but that recession is not vividly impressed on our imagination. There is no continuous and consistent progression from nearer to farther. And this, I think, is by far the best of his works at Burlington House, though it is by no means the most striking. If you were to come upon a series of his landscapes you would certainly feel that my criticisms were unjust, because the first shock of each would be entirely agreeable—before each you would feel, what a lovely scene! what calm, what tranquillity! how good to be in the company of a man who touches that delicate note of reverie!

[1] In this matter of interval, so capital for the landscape painter, the photographer can to some extent become an artist. There is at least one photographer on the staff of *The Times* who seems to me to have a remarkable feeling for this quality.

Nor do I for a moment deny that all that is to the good so far as it goes. But you must not press further—you must not ask for hidden harmonies to reveal themselves gradually to your prolonged gaze, for deeper formal significances to unfold, little by little, as you may before the great landscape painters, before Rubens or Poussin or Cézanne.

With Reynolds, who comes next in order of time, begins the great period of English portraiture. And of him I find it hard to speak as I should like. At the very beginning of my career as a writer on art I made a critical edition of his Discourses, and my study of him led me to regard him with affection for his character, with a strong bias in favour of him as a painter, and with reverent admiration for him as a critic. That admiration of the critic still persists. I still think his Discourses of great value for artists, I still think he was one of the few writers who rarely talked nonsense about art or strained the expression of his feelings with a view to effect. Looking back on my own work, my highest ambition would be to be able to claim that I have striven to carry on his work in his spirit by bringing it into line with the artistic situation of our own day.

PLATE VII

13. GEORGE MORLAND : *Landscape*
National Gallery

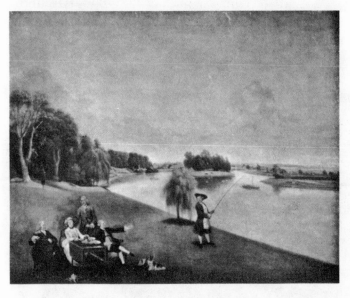

14. JOHANN ZOFFANY: *Garrick entertaining Dr. Johnson*
Earl of Durham Collection

PLATE VIII

16. SIR JOSHUA REYNOLDS : *Countess Spencer*
Earl Spencer Collection

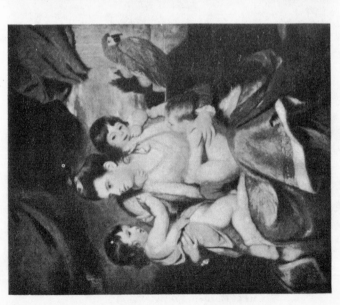

15. SIR JOSHUA REYNOLDS : *Lady Cockburn*
National Gallery

For what, in effect, Reynolds attempted, what he inculcated with persuasive eloquence in his Discourses, was to wean British art from its isolation and provinciality and to bring it into line with the great European tradition as it had been elaborated by the Italians and carried on by Rubens, Rembrandt and Velazquez. He tried to check our tendency to be satisfied with a superficial and lazy pleasure in trivial anecdote and descriptive realism. In short, he was the advocate of plastic as opposed to literary art. He tried to show that the deepest spiritual experiences which art can communicate are only to be expressed by formal relations, by the manner of painting, and not by what is painted. He insisted particularly on the full realization of the volumes, advising his pupils to imagine how a figure would appear from the back as well as from the front presented to the eye, to feel all round it, as it were, and not to be content with describing its contour.

Reynolds looked forward to a great development under the fostering care of the Royal Academy in this direction; he hoped that British Art would take its place in the European tradition and achieve what he called the grand style.

Alas, this dream was never realized. The next period after Reynolds' death did produce one great plastic designer, Constable, but his relations with the Academy were not of the happiest, and it

was France, not England, that understood his message, while England in the nineteenth century enjoyed a veritable debauch of trivial, anecdotic picture-making such as the world had never seen before.

In part this was due to the fact that Reynolds himself confused two things in his doctrine of the grand style. He confused plastic design with the expression in terms of plastic design of a rather rhetorical attitude to life—a rhetoric which aimed at nobility and impressiveness. He identified plastic design too much with the post-Raphaelesque and Michelangelesque art of the Seicento. And the result of this confusion was that those painters who listened to him most attentively, —men like Barry and Haydon—thought that the grand style could be achieved merely by painting vast heroic compositions of empty and inflated figures in absurdly rhetorical gestures. And in both cases it led to financial ruin, and in Haydon's case to suicide. This not only discredited the grand style, but tended to make artists sceptical of any serious æsthetic study whatever and turned them back to the old familiar, easy ways of trivial realism.

It led, too, to violent disparagement of Reynolds himself, to which Cunningham gave voice in a curious passage in his *Lives of the Painters*. He says:

'Barry was a proud artist and a suspicious man.

. . . He followed his own ideas in the course he pursued, but probably he reflected that he was obeying the reiterated injunctions of Sir Joshua, who, constantly, in his public lectures and private counsels, admonished all who loved what was noble and sublime to study the great masters and labour at the grand style. This study had brought Barry to a garret and a crust; the neglect of it had spread the table of Reynolds with that sluttish abundance which Courtenay describes, and put him in a coach with gilded wheels and the seasons painted on its panels.'

Now the fact is as true as the implication is false. Reynolds evidently realized that he had not the gifts for great figure compositions in the manner of the Italians, that he was no Michelangelo, nor even a Tiepolo, and that the utmost he could do was to give to his portraits a more consistent design and a more significant composition. And this brings us back to his work as an artist. And here, as I see it, the situation has a peculiar irony, for the more familiar one becomes with the works of Reynolds, the more one feels that his imposing manner, his air of a master, covers a fundamental emptiness. His pictures so often proclaim themselves masterpieces at the first blush, only to prove their mediocrity when one probes deeper. With a very feeble sense of form, Reynolds often seems to insist that the empty drawing of an arm and hand is the

simplification of a great draughtsman. His very scarce drawings are there to show how little of a draughtsman he was, but he bluffs it with such apparent candour in his painting that one is tempted to take his mastery for granted. In fact he learned to imitate the final results of mastery without going through the preliminaries.

He never quite realized the difficult and painful truth that you cannot lie in art successfully. This is true of his drawing, and still more of his quality as a painter. He was the victim of a very common misunderstanding that certain qualities of paint are beautiful in themselves, and that by study and practice we can acquire these. Thus with his marvellous critical appreciation he admired intensely the density and richness of Rembrandt's paste, and he believed that by trying all sorts of technical dodges, by mixing wax with his pigments, and goodness knows what elaborate cookery, he could give this quality to his pictures. He failed to see that Rembrandt's quality is beautiful because it is the perfect expression of Rembrandt's personal feeling for form. Rembrandt himself did not aim at this quality; it came inevitably out of his endeavour to express the full complexity and richness of his sense of what was before his eyes. It was only because, with his mind fixed on his idea, his hand worked with unconscious freedom that his quality had its rhythmic beauty.

PLATE IX

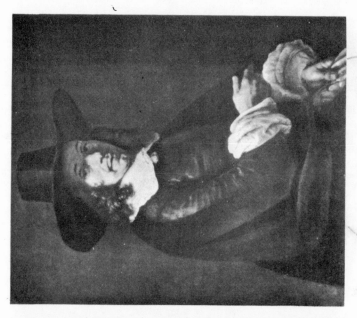

18. REMBRANDT : *Self Portrait*
Ex collection Youssoupoff

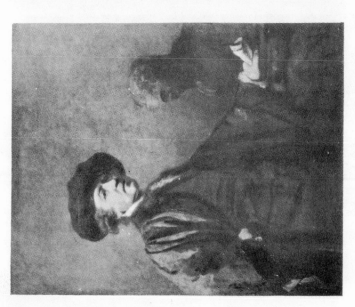

17. SIR JOSHUA REYNOLDS : *Self Portrait*
Royal Academy

PLATE X

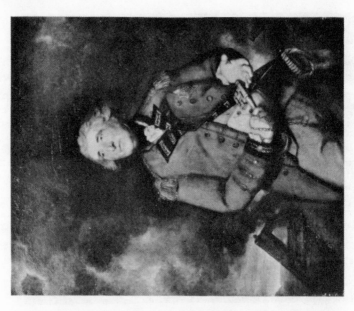

20. Sir Joshua Reynolds :
The Lord Heathfield

National Gallery

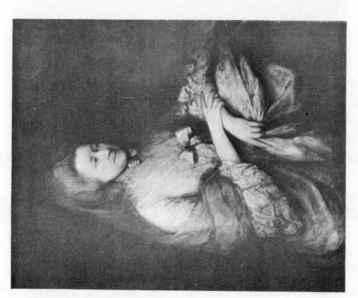

19. Thomas Gainsborough :
Viscountess Folkestone (Mrs. G. Holt)

U.S.A. Collection

And so, when Reynolds tries to paint like Rembrandt, his laboured and loaded pigment, instead of revealing a profound intuition of form, covers up the absence in Reynolds's mind of any firm conviction of form whatever. The picture becomes a dish which is all sauce and no meat.

It would, of course, require at least a whole chapter to attempt to substantiate this judgment. It is the position I have gradually been forced to, and I must leave it at that. Nor do I wish to suggest that Reynolds does not remain, when all this is admitted, a very considerable personality in art. He at least took his art seriously—he at least set the example of a high standard of artistic conscience. He spared no pains to perfect his designs, to revise and improve his compositions, and to put into practice all that he had learned by his critical understanding of the older masters. And he had his reward, at least in this, that his latest work is in many ways his best. If he lacked spontaneity and intuition, he at least had extraordinarily good judgment and taste, and his wide culture made him eminently a man of the world, so that in one respect he is unsurpassed. He knew to a nicety what the social ambience of each of his sitters was, and he is able to convey the feeling of that in his portraits. Each belongs to his proper social sphere.

It was perhaps Van Dyck who first emphasized this social aspect of portraiture—the great portraits

of the Renaissance are too purely and too intensely individual to stress that—but Vandyck did not distinguish; he tended to give to everyone that he painted the same courtly bearing. Reynolds is more penetrating and he does not exaggerate, so that when we think of the distinction of English society in the eighteenth century, of its special note of easy simplicity of manner, its unaffected and unconscious dignity, its discretion, it is round Reynolds's portraits that our imagination crystallizes.

Thus in the portrait of *Countess Spencer and her Daughter* (*Fig. 16*) the note is struck to a nicety and the chiaroscuro and placing of the figures is in perfect harmony with the idea. Or in the *Lady Albemarle* of the National Gallery, again, we feel intimately the kind of life in which such a character was formed, and in this, more than usually with Reynolds, the character of the woman herself comes out with some precision. For, as a rule, his tendency to lose all precision of form in his effort at breadth of handling gives us only a blurred sense of character, though we may feel some kind of likeness to be there.

I think that is true of the *Lady Cockburn and Children* (*Fig. 15*). But what a triumph of learning the design is! I feel sure that almost everything here could be traced to some original by Rubens and the Seicento Italians, but how skilfully the

motives are brought together. It has not the surprise and shock of a fresh discovery in design such as Gainsborough gives us at times. We feel the effort of calculation, but still we must applaud so hard-won a success.

Reynolds had such tact and good sense that even when he feels that rhetoric is called for, the rhetoric is studiously moderate and discreet—not always, I confess, for the *Mrs. Siddons* at Dulwich is an instance of the contrary. But in the *Lord Heathfield* (*Fig. 20*) at least we have a rhetorical portrait which does nothing to shock us. As usual he sees his sitters in their rôle on the stage of life—they are not so much individuals with all their contradictions and complexities as actors who come on in their own rôles. Here no doubt we get some kind of likeness of Lord Heathfield, but much more Lord Heathfield as the type of the man of action. This is perhaps Reynolds's masterpiece; the figure is more surely understood, more consistent in its pose, than is usual, and the placing on the canvas is singularly happy.

As you see, I have chosen only Reynolds's best work, because it is more important to feel what it is that he could give them when he failed.

But I must endeavour to show you, by a comparison, what I mean when I say that, in spite of his tremendous efforts, Reynolds never attained to true plastic feeling. Fundamentally his designs

55

are in the flat with an appearance of solidity and space which is not supported throughout. In the *Portrait of Himself* (*Fig. 17*) there is no doubt he had Rembrandt in his mind, and it has at first sight a striking appearance of richness and depth; but you have only to put a Rembrandt near it to see that nothing in Reynolds's personal vision would have led him to this because this is conceived essentially as flat patterns on the canvas. The three light accents made by the face and hands are beautifully placed on that surface, but the head is made in flat light tones against flat dark ones—it has no real bulk, nor has the hand. The folds of his robe are again beautifully calculated so that the lights and darks make a charming flat pattern, but there is no realization of the body beneath.

And now look at the Rembrandt and see how the first impression is of the bulk and weight of the body and of the head, and how exactly they are related in the picture space. And how the drapery really belongs to that body, moulds and reveals it. Again, there is no flat light anywhere—at every point Rembrandt is creating form in all its plenitude and relief. Reynolds made the common mistake of thinking you could get in by the back way and make a short cut to the final result. In many things you can, but not in art.

GAINSBOROUGH

I shall have learned at least one thing from this Exhibition at Burlington House. I shall have learned more than ever before the consummate beauty and delicacy and the almost unfailing genuineness of Gainsborough's art. For our eighteenth century I feel that he stands in a class apart.

Unlike Reynolds, who so frequently announces a masterpiece and fails to substantiate the claim, Gainsborough never tries to be impressive or noble or dramatic; unlike Reynolds, he has no repertory of artistic devices for making a portrait interesting; he does not contrive strange effects of chiaroscuro to give depth and variety to his composition. He poses the model in a good light and paints him as he sees him. But therein lies the mystery of his art —Gainsborough's manner of vision. First of all he saw and felt plastically; that is to say, he felt the whole body and volume of the figure, felt the intimate connection of each part with all the rest, so that the figure revealed, by its poise and movement, that essential unity. He achieved that detached, contemplative attitude without which we can never seize all the complex relations upon which the plastic continuity and integrity of a human figure depend. It is almost pathetic to reflect with what labour Reynolds tried to achieve this plastic realization of the form and how easily,

how instinctively, Gainsborough succeeded. His figures stand before us perfectly realized and clearly detached from their backgrounds, and the form is defined with such certainty and ease that Gainsborough has no need to insist on it anywhere. However much it is bathed in light and air, however delicate and fragile it may be, its reality and its relation to the space are clearly revealed. Indeed, so certain is his grasp of form that he can dispense with all those strong contrasts of tone to which artists often have recourse; he can rely on the faintest indications of a shadow, the slightest possible contrasts of colour, without endangering the solidity of the construction. And yet more, trusting to that infallible surety of his feeling for the larger relations and for the essential movement of a figure, he could afford to enter into detail without breaking the unity, he could trace with passionate interest the subtler modulations of the surface, give us the finest inclinations and variations in the contour of a cheek or the modelling of an eye. While Reynolds, fearful of losing hold of his broad effect, had to generalize the form, giving a summary indication of its main character, Gainsborough could be almost meticulous in the refinements of his drawing and modelling; he could peer and particularize.

And Gainsborough's vision is at once so clear and so detached from ordinary life that he seems

altogether unconscious of the categories by which
we classify our fellows. If he paints a Duchess, no
doubt she appears as a Duchess in the picture, but
Gainsborough never seems to have been conscious
of it; he gives us living human beings in all the
completeness, the uniqueness and complexity of
their personality, but he does nothing to label them
at all.

Reynolds painted manly portraits and womanly
portraits and childlike portraits—he even painted
military and intellectual and aristocratic portraits.
Gainsborough paints individuals and leaves it at
that. Sir Walter Armstrong, who has written some
admirable pages on both Gainsborough and Rey-
nolds, says that while Gainsborough excels in
women he never painted such a manly portrait as
Reynolds's *Lord Heathfield*. The fact is that Gains-
borough never even painted his men as men or his
women as women. He painted individuals; he did
not underline the fact that they were men or
women, or lords or ladies, or his own bourgeois
daughters. All that comes out by the way; he is at
no pains to tell us about it. He paints human
beings, and he makes them live for us in their par-
ticular personal characters. But even *that* is not
underlined—it emanates from the image as we con-
template it. For it would be a mistake to suppose
that Gainsborough was intensely preoccupied
with the psychological aspect of his sitters. He had

nothing of the intense and penetrating curiosity about the drama of human life of a Rembrandt, nor even that half pathetic, comedic sense which animates Watteau's figures. It is rather that the clarity and sincerity of his vision inevitably bring their character before us. And one guesses too that he never dictated a pose to his sitters; he let his design and his general conception of the picture grow out of whatever appeared most easy and natural to them.

In the portrait of *Uvedale Price, Esq. (Fig. 21)*, for example, the composition—very unusual for the time—was evidently suggested to Gainsborough by the very personal way his model sat. It was that which gave him the idea for this entirely new and spontaneous design in which the rectangles of picture and chair-back, re-echoed with variations in the portfolios and the drawing which the sitter holds, play so ingeniously around the firm set and rectangular mask of the man. And yet it has so natural an air that we feel it must have happened so. Perhaps it did, but it needed Gainsborough to see how significant it was, and to choose so nicely his quantities and relate so beautifully his accents of light and shade as to bring out this harmony of shapes and spaces.

This, too, is a good instance of Gainsborough's interest in the subtleties of form which causes him to enter with more searching and penetrating an

PLATE XI

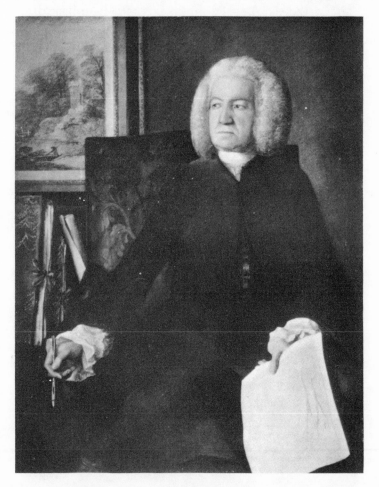

21. THOMAS GAINSBOROUGH : *Uvedale Price, Esq.*
Munich

PLATE XII

22. THOMAS GAINSBOROUGH : *Captain Wade*
Baroness Burton Collection

eye than was at all common in the eighteenth-century tradition into the minute particulars of his sitter's face and hands. But this detailed precision of form is expressed in a touch so flowing and easy, so tremulously sensitive that the details never become insistent—we hardly know that they are there. The unity and continuity of the forms are what strike us: only Gainsborough's passionate pursuit of the details gives to them their satisfying plenitude and richness.

The feeling which we have noticed already here, and which is so constant with Gainsborough's portraits, that he must have come upon his sitter so quietly that nothing has been disturbed or changed is the consummation of art. It heightens the vitality and naturalness of his figures. We get the illusion that we too have come into their presence unobserved and are about to meet them as naturally as if they were alive. There is no feeling of the period about his portraits—we are not conscious of the hundred and fifty years which separate us.

And with all that easy simplicity of presentment there is, none the less, a mood superadded. However plain and direct a statement Gainsborough makes, he can never make it in prose. Always there is just that heightening of the emotional pitch which makes poetry. His figures are enveloped in an atmosphere which is not quite

that of everyday commonplace—as Zoffany's are, for instance. It is transmuted, as though music were going on somewhere. That is inherent in Gainsborough's vision—it is not conscious or deliberate or made up. This peculiar, delicately lyrical mood emanates inevitably from almost everything that he touched. It is bound up, I think, with his rhythmical feeling for form.

Although, as I say, his sense of form was extremely sure and precise (*Fig. 27*), although his vision was clear and in a sense exact, he could only state the forms which he perceived in terms of a beautifully flowing and continuous rhythm. It is this unbroken flowing rhythm, this, as it were, melodious quality in his drawing, which not only binds everything together into an unbroken unity but communicates a peculiar lyrical quality to his imagery.

And his colour is in perfect accord with this melodious quality of his line—indeed it comes almost inevitably out of it, because Gainsborough never painted; he always drew. I must explain this apparently paradoxical statement. I mean that he never used the full possibilities of oil paint, its dense paste, its fatness and unctuosity. Rather he used oils as a kind of water-colour, achieving his forms by laying one thin transparent or semi-opaque stroke beside another or letting them overlap. In this way he attained a peculiarly fresh,

luminous and atmospheric quality which is directly expressive of his habitual mood.[1]

In colour as well as in design Gainsborough allowed the sitter to be the inspiration. His alert receptivity to the impression of the thing seen gave him thus the power to disregard all the usually accepted conventions and make quite new and surprising discoveries. He is one of the few artists at Burlington House who give one the shock of delight which comes from finding the unexpected resolved into a new harmony which we can accept.

Who but Gainsborough would ever have thought of painting—as he did in his *Captain Wade* (*Fig. 22*)—a bright scarlet coat against an

[1] On this point a technical question may be of some interest. The painters of the Renaissance and seventeenth century used for their oil-painting a medium which was probably almost the same as that originally discovered by the van Eycks—it was a medium which allowed of using solid paint with extreme ease and freedom of hand, allowed also of the full range from solid white to purely transparent colours such as we see to perfection in Rubens. Lely inherited this medium, though he used it differently, and through Thornhill it descended to Hogarth. But for some reason neither Reynolds nor Gainsborough seems to have possessed it. Reynolds, as we know, was perpetually searching for devices which would give him the special quality of Rembrandt's pictures. Gainsborough never attempted to vie with older masters. He instinctively discovered a method which was entirely original and perfectly adapted to his idea. His quality is perhaps the most beautiful of any British painter, and I suspect that he never gave much thought to it. It is, like all good quality, beautiful because it expresses perfectly his feeling.

intensely luminous pale sky, and relieving the head seen in full light against a sky of almost the same tone? Indeed, I doubt if any one else in the eighteenth century except perhaps Tiepolo would have dreamed that so luminous a sky could be admitted at all into the grave surroundings of a portrait. Goya, of course, a little later on might have done this, and indeed this portrait seems like an anticipation of him. In fact, this notion was strange enough to shock Gainsborough's contemporaries. When it was first exhibited the figure was seen entirely against an expanse of sky with a low landscape horizon, but the criticisms of what seemed so unlikely a situation led to Gainsborough's revising the design by putting in the building to the right with the steps coming down from the house so as to give the pretext to the figure that he has just come out thence. There can be no doubt, I think, that this is an improvement, for the attraction to the eye of the distant vista to the left does require the balance of the greater mass to the right, and the whole effect is to give a suggestion of movement to the figure which enhances its vitality.

But nothing in all Gainsborough's art is more fascinating than his beginnings when, as a quite untaught boy at Sudbury, the passion for landscape came upon him. Landscape, indeed, was from beginning to end his true passion. And it is partly

PLATE XIII

23. THOMAS GAINSBOROUGH : *Landscape*
P. M. Turner Collection

24. THOMAS GAINSBOROUGH : *Mr. and Mrs. Andrews*
G. W. Andrews Collection

PLATE XIV

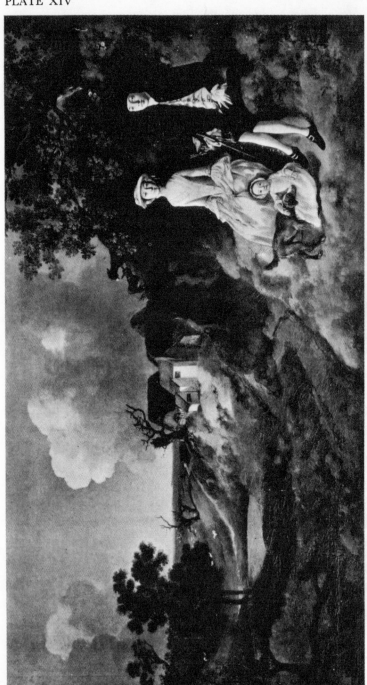

25. THOMAS GAINSBOROUGH: *Mr. and Mrs. Brown of Tunstall*

Sir Philip Sassoon Collection

perhaps because he saw his portraits with the same wide focus as landscape, as so essentially an element in a whole scene, that his portraits are so original.

He said that as a boy he had drawn all the picturesque old tree trunks and such-like details of the country which he covered in his rambles, many of them the prize of truancy from school. He owed this successful truancy to his skill in forging his father's handwriting in letters asking the schoolmaster for leave. When the fraud was discovered the father declared that Thomas was destined to be hung.

In his drawings of landscape (*Fig. 26*) Gainsborough shows even more than in his portraits his independence of the formulas of his day. Here again there is a curiosity, a passionate interest in the forms of nature, which is much more akin to Leonardo da Vinci's drawings than to those of Reynolds.

The early landscape (*Fig. 23*) dates, no doubt, from this early Sudbury period, when he had as yet had no regular instruction. He had doubtless had access to some Dutch paintings by Wynants and others in private collections of the neighbourhood, for he clearly here adopts the Dutch convention for foliage.

How vividly and intensely Gainsborough has concentrated on the idea! He puts everything

down with almost childish simplicity and direct-
ness, but what is remarkable is that he feels every-
where the structure. In imagination he feels all
the movements of the terrain—just how the bank
slopes down to the pool—he follows the undula-
tions right out into the distance, and his tree stands
free in the air—it is no scenic tree silhouetted
against the sky. In spite of its naïve detail, how
well this is composed. How right is the placing of
the tree, how well he has chosen the intervals, so
that the distant space balances the more concen-
trated interest of the farm-house to the right. Here,
at once, he has achieved plastic vision. And though
all his efforts are bent on construction and design
there distils from this quite ordinary East Anglian
landscape a new and personal poetic mood. In a
curious way this reminds me of Giorgione. Gains-
borough's feeling for that farm-house perched on
the sandy slope almost repeats the farm-house
motive which obsessed Giorgione's youth. Here is
the same simplicity and directness of statement
which brings a romantic mood with no romantic
emphasis. Compared with the intentional and
obvious poetry of Wilson this is a piece of literal
prose, but the poetic mood, that none the less
emerges, comes of a deeper understanding of the
vision. The thing is seen with no predetermined
bias towards poetic feeling.

I have compared Gainsborough, perhaps rather

fantastically, to Giorgione, and yet the outside inspiration, such as it is, is all from the Dutch school. Gainsborough shows no familiarity with Italian art—I doubt if he ever had much, and yet he was the one great English master of the eighteenth century who had grasped the Italian conception of plastic design.

This is an example of a curious and rather unexpected phenomenon which recurs more than once in the history of British art. The English more than any other people has always cherished a strong sentimental attachment to Italy and all Italian things. For the cultured Englishman, Italy has always been the home of beauty and romance. And our poets have constantly expressed and fostered this spiritual cult of Italy and Italian art. Think of the vogue of Botticelli in the 'eighties and 'nineties of the last century—nowhere else but in England would that have been conceivable. And you will find a proof of this feeling in the number of pictures of Italian scenes at Burlington House. And yet this influence has all been in the externals of Italian art and Italian landscape; it has been essentially poetical and romantic, and has not implied any real understanding of the Italian conception. Lacking as we do the Latin quality of constructive logic, our artists have tended to see in Italian landscape only its poetical aspect. Both Wilson and J. R. Cozens typify that poetical vision

of Italy, but neither of them grasped the significance of Italian art and its conception of a spatial and plastic construction.

But when our artists turned to the Dutch school the case was different. In the first place, Dutch scenes were not surrounded by any halo of romantic beauty and strangeness, and the Dutch masters had not treated them from the poetical point of view. But though superficially Dutch landscape painting is so utterly unlike Italian, the Dutch had by some means arrived at an understanding of spatial and plastic design. They, too, constructed their designs in three dimensions, and not in the flat. And so it happened that our artists learned much more of the essential Italian idiom of design when they studied the Dutchmen than when they went to Giorgione, Claude and Poussin. And of all English artists, at least until Constable, Gainsborough grasped this idea most completely.

Gainsborough seems quickly to have attracted the attention of the local gentry to his talents, and the portrait of *Mr. and Mrs. Brown* (*Fig.* 25) shows him creating a peculiar genre in which the sitters are almost reduced to the position of figures in a landscape. Not quite, however, because out of deference to them he has given to them a sharpness slightly out of key with the rest of the design. On the other hand, they are relegated to a small space on the right-hand side of a long landscape com-

PLATE XV

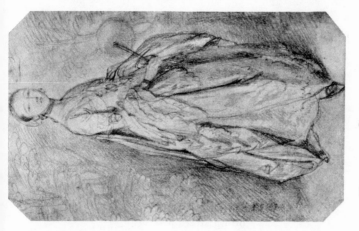

27. THOMAS GAINSBOROUGH :
Drawing of a Woman
British Museum

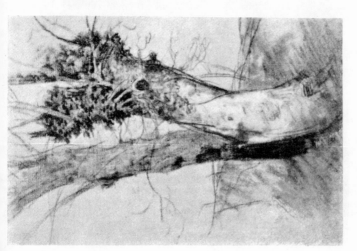

26. THOMAS GAINSBOROUGH :
Drawing of a Tree
P. M. Turner Collection

PLATE XVI

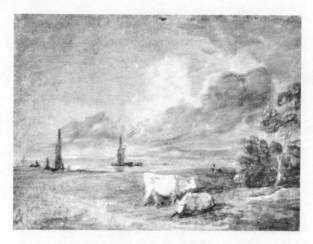

28. THOMAS GAINSBOROUGH:
Landscape Drawing
British Museum

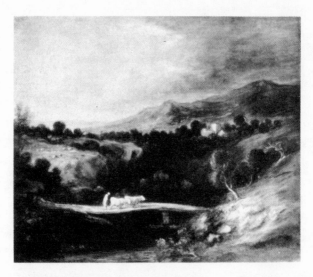

29. THOMAS GAINSBOROUGH : *Landscape*
National Gallery

position. He used for them almost the same land-scape as that shown in *Fig. 23*, and he managed to achieve a very new and harmoniously balanced design by playing the strongly accented figures against a wide stretch of valley and a strongly marked cloudy sky.

Almost every one of these early portraits is a pure delight, but that of *Mr. and Mrs. Andrews* (*Fig. 24*) is perhaps the most striking of all. And what a charming formula it was for the portrait of a country gentleman who was just as proud of his estate as of his wife and his own best clothes and gun, and so has had them all done in one convenient little picture by the local genius. A de-lightful air of rustic simplicity and well-being per-vades the whole transaction. And then, by a miracle, this local genius had real genius and has divined a new relation of figure to landscape, has hinted, too, at a whole new conception of landscape; for never before was there in a landscape such freshness of atmosphere, such gaiety and naturalness, so little of any pictorial convention. It seems but a step from that to our modern notion of landscape with all that new range of colour which we owe to the Impressionists.

Alas! Gainsborough never took that step, nor did he ever explore that exciting vista of a new art of figure and landscape which he here hints at. There was no one at hand to guess at all that this

contained in germ—no patrons were there, such as those who scrambled for Giorgione's poesies, to give Gainsborough the chance to work out that theme on pure imaginative lines—to expand a picnic into a new version of the *fête-champêtre*, to people English landscapes with figures of more than mortal mould; no one even to give him the chance Watteau had to people the English parks with the puppets of a rare and poetical comedy of manners. Gainsborough alone could have built us our special Earthly Paradise, such as Giorgione and Watteau had made for Italy and France. He would have given to it, one feels, that peculiarly delicate note of lyrical reverie which sounds again and again through our poetry, but which is missing in our art. Gainsborough was sacrificed to our exclusive love of the portrait—it is almost a national vice, I sometimes think.

For though Gainsborough turned the portrait into pure poetry in the end it destroyed him. He could not get the time or opportunity to feed his genius on new experiences, to strain his powers on new and more difficult problems; he became ever more facile and more pleasingly elegant. His rhythm got ever rapider and more insistent, until its melodious phrasing became a mannerism empty of all fresh content. It would always pull a portrait through, and that was all he asked of it. And so, alas, Mr. and Mrs. Andrews went home

quite contented and hung up the portrait in the drawing-room,[1] and Gainsborough went back to Sudbury quite contented too with his modest fee, and a matter so big with future possibilities ended there, except that portrait followed portrait till the end of his life.

In these early portraits we find that gradually the focus shifts so as to bring the figure into greater prominence. In his *Mr. Plampin* the figure is so enlarged that the pose, with leg stretched out along a bank of earth, enters largely into the composition, the leading lines of which follow or echo those of the figure. Finally, in the lovely little picture of *Heneage Lloyd and his Sister* there is a marked change, the figures having been carefully studied from life whilst the landscape appears to have been invented simply as a background. It lacks any definite character; it has none of the consistency and reality of the others. Gainsborough has already upset that delicate balance between the two elements which so charms us in the *Mr. and Mrs. Andrews*. He is approaching his maturer practice of setting the figure against a generalized formula for foliage and sky. No doubt this change was inevitable since portraiture was the only

[1]Did Mr. and Mrs. Andrews take it home or not? The question is suggested by the fact that Mrs. Andrews was meant to hold a dead pheasant in her hand, but the pheasant was not forthcoming and the picture awaited a fortunate shot and eventually was never finished.

avenue that opened for Gainsborough. That fascinating equipoise of figure and landscape of the early work could only have been carried on with a figure design more closely adapted both in form and in its associations with landscape. It was impossible to mould the forms and poses of casual sitters to so purely imaginative an end. In the event landscape had to become purely accessory, though even so it plays the most exquisite accompaniment to the main theme, as we saw in the *Captain Wade* and as we find in the marvellous portrait of *Mr. Schomberg* in the National Gallery.

But landscape was Gainsborough's real passion, and in his earlier period he was able to work at pure landscape. The most important of these is the *Cornard Wood* of the National Gallery. It is in effect a transposition of a Dutch landscape into an English mood, and with a freshness and delicacy of feeling which is entirely personal to Gainsborough; and, with that, a franker acceptance of the colour of nature than Hobbema or Ruysdael allowed. Beside them, no doubt, it would look a little fragile and over subtle; it lacks their forcible construction and vigorous relief. But though it is not emphasized, the relief and the spatial construction are none the less felt, and perhaps that very delicacy and understatement of contrast conduces to the dreamy tranquillity of its mood. The *Dedham*, also

in the National Gallery, owes less to Dutch notions of composition. It is evidently taken directly from nature, and Gainsborough has accepted a subject from which most landscape painters would turn at once in despair of interpreting its complications. The focus of the whole picture is the sunlit valley with the strong accent of its church tower, but this is seen through the trunks and branches of trees which tend to arrest our imagined movement and to complicate the forms. This accent is well to the left of the picture and is reinforced by the brilliant clearing in the sky above, and yet Gainsborough manages to establish an equilibrium by opposing to the right nothing but expanses of dull cloud seen over trees in a dark penumbra. It is an example of the way in which Gainsborough's alert receptivity to the significance of formal relations enables him to pull off the most improbable wagers with nature.

Almost any account of landscape composition would proscribe such an arrangement. One fancies that Gainsborough had so vivid a sense of the complexity and the unexpected possibilities of appearances that he was sceptical about the possibility of laying down any laws. It was this that prompted him, when Sir Joshua declared that the main mass of a picture could not be blue, instantly to paint the *Blue Boy* so as to disprove it. I should not have liked him to hear one of my lectures for

fear he should go home and paint a picture to upset all my theories.

These early landscapes are astonishingly near to modern landscape in their outlook—far nearer, in fact, than those which belong to his later periods. We can understand how much they meant to Constable, whose passionate devotion to them is well known.

The little landscape drawing (*Fig. 28*) in the British Museum approximates in its breadth to the later style, but is still close to nature. It shows Gainsborough's infallible sense of design in the perfect placing of the accents made by the barge sails which divide and measure the picture space for us. And here, with only a delicate wash of greys and whites on a brown ground, Gainsborough has hinted at the whole colour effect of the scene. It has the space and luminosity of a Cuyp with just that note of lyrical intensity which Gainsborough alone could evoke.

When once Gainsborough had moved to Bath and started on his career as a portrait painter, he never seems to have found time to carry on so intensive a study of nature. But he did not, for that, abandon landscape altogether. He continued to do numerous chalk and wash drawings of landscape designs. It is said that he got suggestions for his compositions by putting together lumps of coal on the table and illuminating them in various ways.

He developed thus a kind of special shorthand notation of landscape themes which satisfied his creative instinct even when he could not give time to carry them out completely in oil paintings. In this notation, written in Gainsborough's exquisitely rhythmical hand, there were more or less fixed symbols for trees, rocks, sky and cloud, and he combined and recombined them in endless variations, often hitting upon the happiest and most exquisitely balanced systems. But he treated these drawings as the amusements of his leisure. They showed all too plainly that he had given up the game, that he was never going to create that new landscape art that he had hoped for; for in these drawings he falls back on the regular convention of the classic landscape or at least on his own variety of that. There is scarcely ever the surprise of an unexpected conjunction of forms, of a new discovery of space, and, more than that, gradually his symbol for tree and rock forms became fixed—he never enriched it by new observations; it became one of those typical eighteenth-century generalized summaries of natural form which we accept because of their elegance, and which in the end bore us by their extreme fluency and emptiness. It becomes like the poetic diction of the day, which avoids the contact with particular things; for which all birds are 'the feathered tribe' and cows a 'lowing herd'. The drawing in *Fig. 23* is,

for instance, far less modern than Gainsborough's early works; he is no longer trying to find harmonies to express new experiences; he is fitting his material to his habitual harmony.

But though we may regret this abandonment of a greater promise, we need not, therefore, be blind to the exquisite beauty of these. The rhythm flows unbroken through every transition, binding the parts into a perfectly legible unity. Gainsborough is one of the few English artists who leave no holes in their designs. This is a piece of artists' slang, but it expresses an important quality. It means that the construction is complete throughout, that there are no gaps in the texture, no places where the artist is not sure what is happening. It means that every plane holds in its proper place and is consistent with all the others. In many pictures we find here and there motives that the artist has understood and fully realized, but in others he has not clearly realized anything, and his statements are vague and indeterminate. But Gainsborough's designs hold right through.

Sometimes, even in the later drawings, we get surprises. He finds themes that recall the remoter imaginative suggestions of his early landscapes, but expressed with a greater breadth and ease. This drawing (*Fig. 31*), for instance, is very far from the normal eighteenth-century convention, for Gainsborough has built his design out of the play of rect-

PLATE XVII

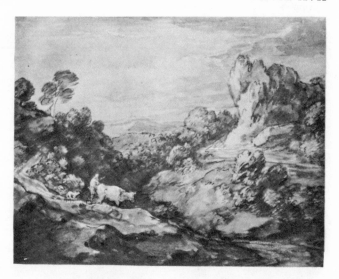

30. THOMAS GAINSBOROUGH : *Drawing*
P. M. Turner Collection

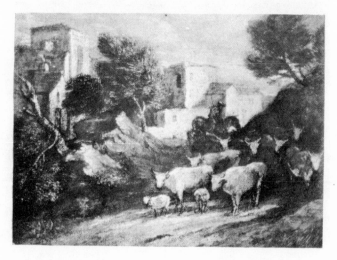

31. THOMAS GAINSBOROUGH : *Drawing*
Victor Koch Collection

PLATE XVIII

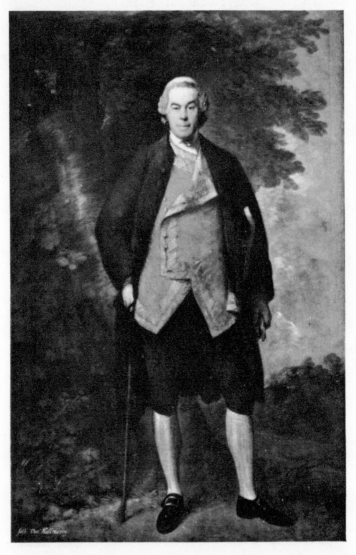

32. THOMAS GAINSBOROUGH: *The Lord Kilmorey*
Earl of Kilmorey Collection

angular forms, one against another, which build up a complex structure, intensely solid and coherent, with a vivid feeling for movements in depths. Only a truly plastic imagination could have conceived landscape thus.

But such drawings are rare, and even when, as still occasionally happened, Gainsborough found time to carry out a landscape in oil it was generally little more than an enlargement of some drawing. The same facile but delightful scribble spreads his generalized foliage across the sky, and the figures fit as easily into the dominant tune. And never again, as in the early landscapes and portraits, does he accept the unforeseen quality of some shifting light on valley or wood; the same brownish shadows melt harmoniously into blueish greens and blues. It is lovely, but it is too lazily delightful.

There is great danger, I think, to an artist who has a strong personal rhythm which comes to him naturally and inevitably. Unless he constantly strains it by the effort to make it take in new and refractory material it becomes stereotyped. We notice the same thing in poets like Swinburne, whose melody is at once personal to them and strongly marked. In the end the tune runs on in the artist's head and words and ideas come tripping to it, but they are not really the right words, and the ideas are not really worth expressing.

There is, however, at least one landscape of this period which is exceptional—the small mountainous landscape (*Fig. 30*) in the National Gallery. Though I suspect that it is entirely imaginary and made without any direct inspiration from nature, it is extraordinary to what an extent Gainsborough's feeling for form has given it richness and body throughout, how full of substance it is in its continuous plastic modulation—and with what felicity he has placed the sharp accent of light on the cows crossing the bridge, and how admirably the gleam of light on the right foreground balances the invitation into the luminous distances to the left.

But let us return again for a moment to the portraits, because in them Gainsborough was continually up against nature, and continued for long to find therein the inspiration for new ideas of design, new colour harmonies. And again and again he would become absorbed in the character of a head and use to the full his imaginative understanding in order to find for it the completest expression within his scope.

He is almost at his best before such a sitter as *Elizabeth, Viscountess Folkestone* (*Fig. 19*), where time has left its mark and given to the forms a complexity and subtlety which needed his sympathetic and almost caressing observation. He treats such a theme with infinite tenderness and yet without flattery or make-believe, and as usual

78

he penetrates to the inner life. This is the portrait of a distinguished lady, but we scarcely think of that—it is primarily this individual woman whose life had engraved her features so delicately.

Or, again, the *Lord Kilmorey* (*Fig. 32*). How right Gainsborough was to do him just like this! One feels sure that, whenever one met him, he would always be like that, facing you squarely with his legs wide apart and his hands thrust down—you would never catch him in a less abrupt and positive pose, and so Gainsborough painted him just as he was, and tried no dodges with any elaborate design.

There remain, of course, a whole lot of eighteenth-century painters who produced more or less competent, more or less agreeable work—men like Cotes, Northcote, Romney, Opie, Hoppner, Raeburn. Opie at times in his youth gave promises of something more solid and individual, but his later work only shows how illusory this was. Only two, I think, Romney and Raeburn, struck a definite personal note; Romney with so feeble a talent that it is a perpetual wonder that anyone ever listened to it, and Raeburn with almost an excess of talent —certainly a talent out of proportion to his essentially commonplace vision and vulgar dramatic

emphasis. Reynolds, for all his refinement of taste, had already given, now and again, ominous signs of a growing falsity and laxity in the sentimental attitude to life, and most of these artists exploited that increasingly. But I must say a few words about two artists of this end of the century.

One of these is Morland, who is, I think, too much neglected. Morland was a specimen of that rare, but much admired, species, the Bohemian artist. As you know, nearly all artists have been typically bourgeois people, and generally led the most settled and regular lives, but fortunately there occur from time to time a few true Bohemians who keep alive the pleasant legend about the artist and leave the door just ajar for romance. Anyhow, Morland refused to come to terms with society; he was a true pot-house artist, rather after the Dutch pattern. But, alas, he did not live up to his opportunities or his very genuine powers. He allowed himself to be humbugged about the very people he chose to live with. Though he would have nothing to do with the polite world, he accepted from it the purely fictitious Arcadian figure of the simple peasant—the peasant as he appeared in illustrations to edifying books for the young, where the good young lady delights in distributing alms to the deserving poor.

Even his trees, his cottages and his cart horses take on something of the same unreal air of pro-

PLATE XIX

33. DAVID COX: *Drawing*
Sir Robert Witt Collection

34. JOHN CONSTABLE: *Watercolour*
Victoria and Albert Museum

PLATE XX

36. WILLIAM BLAKE : *Moses and the Golden Calf*

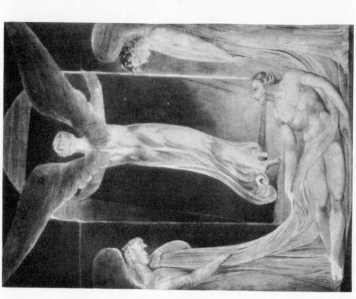

35. WILLIAM BLAKE : *The Sepulchre*
Mrs. Sydney Morse Collection

perties in a pastoral scene. Only one thing escapes
the touch of this deforming idealization, and that
is his pigs; and fortunately he was fond of painting
pigs. And yet there must have been scenes in those
country pot-houses where he spent most of his
time and drank himself into debt—there must have
been scenes which were worthy of his utmost
efforts. If only he had had the sincerity of a Brauer
or an Ostade he might have been at least a great
minor master. For he was, after all, one of the best
painters, in the strict sense of the word, of the
eighteenth century. His pictures hold up through-
out, the transitions of tone are fully understood and
kept in a single focus. Like Gainsborough's, his
pictures have no holes in them, and his composition
is often remarkably coherent, though never strik-
ing. Finally, he used his full and flowing pigment
with freedom and a fine feeling for accents of
light and shade, and his silvery colour has an
almost French elegance as of a rustic English
Fragonard. He was the victim of late eighteenth-
century sentimentality. It was a disease which he
might, one thinks, have escaped in the pot-house
and the debtors' prison, but perhaps sentimen-
tality is as rife there as anywhere.

There is, however, one little landscape by him
in the National Gallery (*Fig. 13*) in which his deli-
cate silvery tonality gains its full effect. Apart from
Gainsborough's, there are few eighteenth-century

landscapes which show such sensibility and under-
standing. It is so small a picture that it might pass
unnoticed, but it gives Morland the right to be
remembered.

The other eighteenth-century artist is a much
more formidable affair—William Blake. I think
it was Burke who said, 'I cannot hope now to re-
ceive from the greatest masterpieces as intense an
emotion as I got in my youth from works that my
maturer taste condemns'. Probably everyone who
is old recognizes the truth of this, and we inevit-
ably think we are wiser now than we were. But
who is to judge between our two selves? There is, of
course, this much to be said for the old man's
view, that in youth we go to works of art rather to
release the pressure of internal emotion than to get
experiences from outside. In effect we put to the
credit of the work of art much that we have con-
tributed from ourselves. They help us to self-
realization. I am led to these reflections, when I
ponder on this period of British art, because in my
youth two artists exercised a profound influence
on me. Turner already when I was quite a boy
and Blake when I was a young man. Both were a
release from a world which seemed altogether too
drab and matter of fact for my aspirations. Prob-

ably those who were not brought up in a rather strict, Victorian, middle-class home will not understand the vehemence of this impulse. And now, alas, about neither of them can I hope to find the impassioned phrases that I might once have used. Perhaps one is never fair to fallen idols—we resent their incapacity to provoke our worship.

Both these artists are distinguished by the exuberance and vehemence of their imagination, i.e. what is usually called imagination, though I should like to go back to the eighteenth-century word of 'invention', because imagination is too wide a word and should be applicable to artists like Velazquez and Constable, who were almost lacking in invention. In Blake's case at least invention was, I think, imposed on him with the authority of complete hallucination. He was perfectly honest when he said that what he saw with his mind's eye was far more precise and distinct than what he got by his vision of the outer world.

Blake, indeed, was an almost perfect example of the visionary. Now you will notice that the striking thing about the visionary is that he is not interested in vision, in the sense in which we use that word of artists, of people who happen to be deeply interested in the appearances of nature as revealed by sight. The visionary is not interested in vision because he keeps his eyes shut, as we do while we dream; for the visionary is one who dreams

whilst he is awake and, in extreme cases, like that of Blake, even with his eyes open. Of course those inner visions, whether of ordinary dreams or wide-awake dreams, make use of our stored-up visual memories, but every one, from early childhood on, has inevitably garnered a large number of these. But just as a great many people go through life without looking attentively at appearances, so the visionary has no need to probe any further; he has enough ready to hand for the fabrication of innumerable dream structures. Thus it came about that Blake scarcely looked at the external world at all, or only with a casual, superficial glance, never with the intense, contemplative gaze of the artist. He was far too much excited and interested in that vast interior phantasmagoria which passed across the screen of his inner vision. It was to the record of that he bent his executive powers.

The source of that phantom world, more real to him than our reality, was, I surmise, the tremendous imagery of the Old Testament. It was words like 'the deep', 'the Lord of hosts', 'the firmament', 'the foundations of the earth', with their vast and vague cosmic references that stirred his spirit and forced him to refashion his conception into his own cosmogony with its Thels and Gorgonoozas and Enotharmons. And while his conscious mind brooded on these ideas his sub-

PLATE XXI

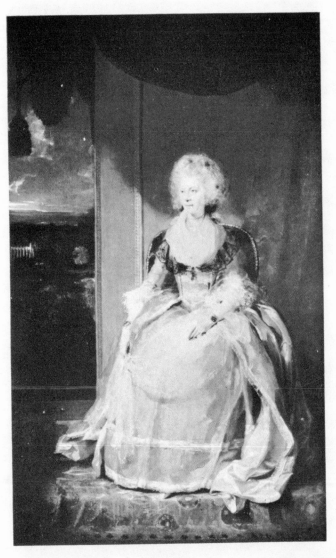

37. SIR THOMAS LAWRENCE : *Queen Charlotte*
National Gallery

PLATE XXII

39. SIR THOMAS LAWRENCE:
Miss Carrington

Collection of Misses Hunt, Boston

38. SIR THOMAS LAWRENCE: *Self Portrait*
Washington

conscious mind cast up before his inner eye complete images which had the objectivity of dreams, only with a far greater clarity.

The process must, one thinks, have been closely analogous to that which led to *Khubla Khan* and the *Ancient Mariner*, and which has been so completely analyzed for us [1] that we know what the original material was and how it was transmuted by Coleridge's unconscious cerebration. And with Blake, too, we know roughly what the bricks were which his unconscious put together for him to build this grandiose dream world. Largely they were Flaxman's, and perhaps Fuseli's, drawings in a peculiar effete and emasculate version of Græco-Roman originals—those, and perhaps engravings from Michelangelo, were the stuff that lay ready to hand and that his subconscious mind rearranged into such strange, and often moving, justaposition that Blake regarded them as revelations from another world. Thus his imagery has the haunting persuasiveness of vivid dreams although the actual shapes are too empty and insignificant, too much mere generalized symbols for things—and weak symbols at that—to move us. The result is that the first shock of wonder at the unfamiliar and yet compelling situation is the best that one can get out of his designs, and one tends to feel them less, the more one studies them. Thus in the *River of*

[1] In *The Road to Xanadu*, by J. Livingstone Lowes.

Life it is the vivid idea it gives of the figures moving through the water by means of some mysterious power, like that of flight in a dream, that satisfies vague yet profound instinctive longings.

The appeal of all his imagery is to some kind of dream life where we are released from the physical constraint of our bodily existence. In none of them is there any attempt to face reality and to probe deeper into its possible spiritual significance which I believe to be the function of all the greatest art. All the same, in its way, this dream art is strangely potent, for, just as the matter-of-fact stories of old sea voyagers were transmuted by Coleridge's unconscious into vibrant and compelling phrases, so the dreary anæmic elegances of Flaxman become somehow vitalized by Blake's internal frenzy, and, moreover, feeble as the actual shapes are, they are sometimes put together with considerable unconscious art. His subconscious did evidently organize them into bold and curiously primitive compositions. So that when he declared that the Byzantine style had been divinely revealed to him it looks as though he had some justification—by the by, I wonder what he, or anyone, knew then of the Byzantine style. Thus *The Angel rolling the Stone from the Sepulchre (Fig. 35)* is a remarkable design in the flat—the sort of triptych into which he has divided it is finely proportioned, and the spreading wings, just going out at the top, are significantly

placed. Even the spaces between the figures are felt as part of the pattern. Blake is a curious instance of that love of line which is noticeable in early British art. He translates Michelangelo into mere line, line which does not evoke volume at all, but remains pure line; and he lets his lines wave about in those meandering, nerveless curves which were so beloved by the Celtic craftsmen long before. He shows in this a strange atavism which may not be unconnected with his mental malady—for personally I cannot doubt that he was the victim, but a very happy victim, of a well-recognized form of mental disease.[1]

As a proof of this extraordinary linear conception, look at the curious sort of basket work of interlacing strands of which he makes his figures, weaving together a number of imaginary muscles dimly remembered from Michelangelo prints. But these fantastically muscular figures have not a bone in their bodies to which the muscles could be fixed. And all this elaborate musculature decorates a figure which has the wavy unresistance of seaweed.

I consider that his *Moses and the Golden Calf* (*Fig. 36*) is perhaps the finest of all Blake's compositions. It is one of his so-called tempera paintings. Goodness knows what concoctions he used, for they have all crumbled into rather fascinating

[1] v. *Blake*, by Alan Clutton-Brock (Gerald Duckworth and Co., Ltd.).

ruins, a condition which, indeed, adds to their suggestive power, for we tend to read into them something of mass and volume which is not really expressed. But the quality here which is undoubtedly Blake's is again the intensely original composition —the impressiveness produced by this violent compression of the forms into the rectangle. And here too the pose of the Moses does suggest tremendous energy and force. It might almost be amusing as a caricature of Michelangelo's mannerisms were it not that Blake's intensity of conviction just keeps us from ribaldry.

Blake was born in 1758—the artists I am about to speak of were born from about 1770 onwards, and therefore their activity lies in the nineteenth century.

The battle of Waterloo, which is one of the two dates in English history which we all know, forms a convenient moment at which to look at the situation of British art.

That date marks a moment of supreme interest in the history of British art—for I must now definitely call it *British*, and not English art.

Waterloo had proved that even a Napoleon could not prevail against the dogged opposition of the British nation and the patient tenacity of a

British general. And our position in letters was no less striking, with Scott and Byron giving the new note of the time.

And as for our art—never before, in all our history, had we such a splendid array of talent. There was Raeburn, Geddes, Wilkie, Crome, Cotman, Girtin, Turner, Constable, and as for Lawrence, he held a position such as no artist had had since Rubens. All the crowned heads of Europe competed for the honour of sitting to him; he had to go to Rome to paint the Pope; he was the pride of George IV—for we had a king who, whatever his faults, had a genuine passion for fine art and had, too, the princely notion of constructive imagination and ambition which seemed extinct since the days of Louis XIV. The Waterloo chamber at Windsor enshrines this ambition. It is like a kind of pathetic afterglow of Renaissance ideas and of the artistic function of royal persons. It is the English counterpart of Marie de' Medici's great decorations, with Lawrence playing the part of Rubens. It is a long time since I have seen that, but my impression is that Lawrence comes through the ordeal as few of our artists could have done.

Such, then, was the situation—never before or since was British art so evidently pre-eminent— there was this glittering figure of Lawrence: Bonington was in a few years to start, through Delacroix, the whole of French Romanticism:

Constable was to electrify Paris with a new revelation of natural colour which held the key to the later developments of European art, and none could foretell what Turner's magical powers might not accomplish.

England seemed to be ready for a new Renaissance, and then, by 1850, scarcely anything was left of this glorious promise; British art had sunk to a level of trivial ineptitude. Landseer had become the Monarch of the Glen, and Frith was teaching people to give up all this nonsense about art.

It was a tragic change, not only in our art, but in the whole temper and character of our civilization. In those years we became slaves to Philistinism, Puritanism and gross sentimentality. You can see it reflected in Carlyle, who from a disciple of Goethe turned into the groaning addict to the dangerous drug of righteous indignation; you can hear it through the droning pomposity of Wordsworth's later verse.

What a subject for a tragic history, one which I do not think anyone has written in detail. And as to the cause—the Reform Bill and democracy—the industrial revolution? I do not know enough to give an answer; I only note it, as it shows itself in art. And one thing we must remember, almost everywhere in the world art became moribund in the nineteenth century; only in France was the sacred flame kept alight by a succession of heroic figures.

Indeed, a malign fate seems to have presided over the destinies of our spiritual life—Shelley, Keats, Byron—all cut off in youth; and in art, Bonington in 1828, Lawrence in 1830 and Wilkie in 1841. This surely must be one of the great factors, and we must call it an evil chance. But we must not put too much down to misfortune, for we cannot avoid a suspicion that there was, when all is said and done, something wrong about the splendid promise itself. Something creeps in already into the art of Lawrence, Wilkie and Bonington which suggests a new and ominous tendency.

Let us look, then, more closely at Lawrence. It is a great disappointment to me that Lawrence is so ill represented at Burlington House, because Lawrence is one of our greatest masters. I use the word master in rather a narrow sense. I do not mean by it quite the same as one of our greatest artists. I mean that he showed a consummate mastery over the means of artistic expression—that he had an unerring eye and hand. That is to say, that when he looked at anything, say a man's head, he seized at once the relations and proportions of its parts, and could draw this with unwavering precision. In this respect a man like Reynolds was a bungler in comparison, and even Gainsborough was hardly his equal. But whereas in Gainsborough's case the vision was, as it were, polarized

by a peculiar melodious rhythm which was in-
herent in him, the vision that Lawrence grasped
so surely was relatively commonplace and undis-
tinguished.

Lawrence was an infant prodigy; from his
earliest boyhood he had possessed this specific gift
of the artist, and distinguished people would go
out of their way in order to stop at his father's inn
near Bath in order to get the infant prodigy to
take their likenesses. And, unlike Gainsborough,
he was a predestined portrait painter. Not only
did he scarcely ever do anything else, he had appar-
ently no desire to do so. But his gift for portraiture
was so unmistakable that at the age of twenty-one
he was called to Windsor to do the portrait of
Queen Charlotte (*Fig. 37*), which fortunately now
hangs in the National Gallery. It is an astonishing
performance. In the royal presence this boy had
not the least flicker of hesitation—nothing could
shake his complete self-confidence. It gives one
the impression of having been done at full speed,
without the least alteration or correction any-
where, carried through, as it is, with such fluent
ease and such consistency of light and colour. No
one since Rubens had possessed quite this kind of
competence. And the tone is perfectly held, the
accents of light are never uniform or monotonous,
the transitions follow one another rhythmically
throughout the whole design. Lawrence was not a

PLATE XXIII

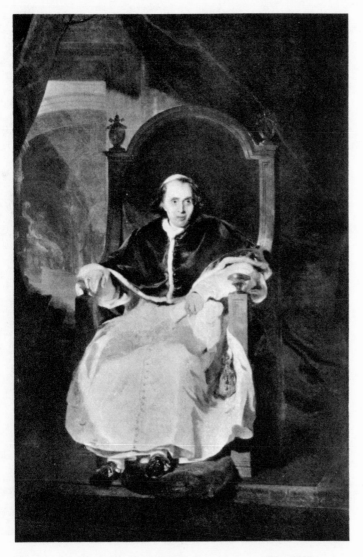

40. SIR THOMAS LAWRENCE : *Pius VII*
The Royal Collection, Windsor
By Gracious Permission of His Majesty The King

PLATE XXIV

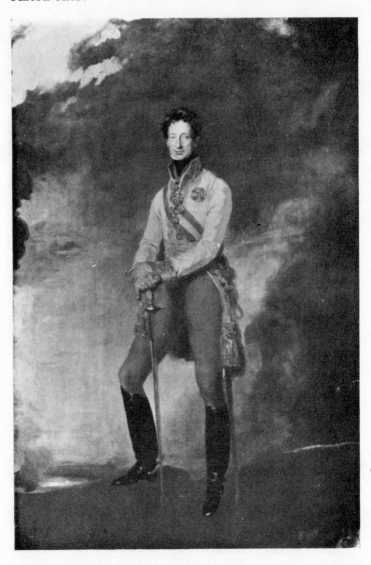

41. Sir Thomas Lawrence : *Archduke Charles of Austria*
The Royal Collection, Windsor
By Gracious Permission of His Majesty The King

great colourist, but here he has confined himself within a rather narrow range of bluish-green, whites and greys—a kind of aquamarine tint, which is certainly harmonious. Already, perhaps, one notes a tendency to mark the accents of shadow and of darker local colour with too staccato a touch.

And here we touch on what was to become a dangerous quality, on what indicates a subtle degradation of taste. It becomes portentous in his later portraits of women, as you can see by the *Miss Carrington* (*Fig. 39*), where everything is falsified in order to satisfy a preposterous idea of feminine fragility and elegance. This was no doubt one of the signs of the time. Women were gradually unlearning all the comparatively sensible notions about themselves which marked the eighteenth century—they were learning to have vapours, to scream at mice, to eat nothing at meals and make up for it in private, and generally to behave like angelic idiots. It was one of the penalties we had to pay for romanticism.

In Lawrence's men's portraits this is not nearly so apparent. The self portrait (*Fig. 38*), which must be fairly early, is for him almost subtle and delicate in its modelling, and it is admirable in its combination of minute precision and breadth.

It was said by his contemporaries that Lawrence drew eyes better than Titian; the fact is that

he drew them a little too well, or rather he drew them with too much insistence on their transparence and limpidity. It is here just the one accent that slightly impairs the unity of this beautiful head. It is one of the most obvious tricks for giving a false air of spirit and intensity to a portrait.

In his portrait of *William Pitt*, the trick is glaring, and it is used to produce a vulgarly theatrical effectiveness. What a contrast to the decent and modest rhetoric of Reynolds's *Lord Heathfield*!

It is still evident even in his *Pius VII* (*Fig. 40*). The glitter in the eyes accents the idea of the body being worn out by the spirit, so dear to the new romantic idealism. But, all the same, what a grand portrait! Again we have to think of Rubens for anything like the assurance and ease with which this composition is designed and carried through. How tactfully and yet effectively he has suggested the immense vistas of the Vatican behind; how right is the proportion of the figure to the space, and what character in the movements of the hands and feet! It is in the grand tradition, and really no unworthy successor to the great papal portraits of the past. A strange thing about Lawrence is that, the more exacting the task; the more he is expected to do a grand ceremonial portrait—something that is at once a portrait and a public monument—the better he succeeds.

The portrait of *Charles Duke of Austria* (*Fig. 41*) is

another example. It is one of the Waterloo series, and how splendidly he has succeeded! And again, how nicely are the proportions of the figure adjusted to the whole space, and how well he has managed without any theatrical effect of light and shade to give the figure its proper dominance.

One cannot possibly deny that Lawrence painted a great many really bad pictures, flashy in their tone contrasts and false in their emphasis. How much of that was inherent in him and how much due to his time it is hard to estimate.

But when nothing led him astray, how good he was! The National Gallery portrait of *Mr. Sansom*, for instance, is a real masterpiece. The placing, the design, the movement of the figure, are all delightfully just, and though there is mastery in every touch there is no swagger or ostentation of any kind.

Lawrence's was a singularly attractive character. His unparalleled success never turned his head, and he had the extraordinary modesty to say, 'I do not for a moment suppose that my reputation will ever stand as high after my death as it has been in my lifetime'. That is true enough, but with all his faults we cannot afford not to salute a master. And one deep debt of gratitude we owe him—he was largely instrumental in the starting of the National Gallery by the purchase of the Angerstein Collection, for he had a passionate admiration

of the old masters, and himself made an unrivalled collection of drawings which ought to have been bought for the nation.

We must turn now to Wilkie. Here again Burlington House does not do him justice. No doubt there was too much of the industrious apprentice about Wilkie. He believed a little too much in learning the tricks of the trade. He studied the Dutch masters with extreme assiduity, but rather too much with a view to making use of them and not enough to enrich his own vision. Perhaps, indeed, he had no very marked personal vision. But though he owed more to assiduity than to his native gift, he had a real sensibility to form. Some of his drawings may almost be compared to those of Ingres in the sensitiveness of the line and the plentitude of the form; they have nothing of the mannered calligraphy which was usual at the time.

And he drew in paint with the same firmness and precision. His figures, however commonplace in conception, are always solidly constructed. It is true that in his painting there is a certain slipperiness in the transitions, a suggestion of an unpleasantly satiny surface which again belongs to the new taste for elegance at all costs. Finally the story-telling aspect of the picture tends to become

PLATE XXV

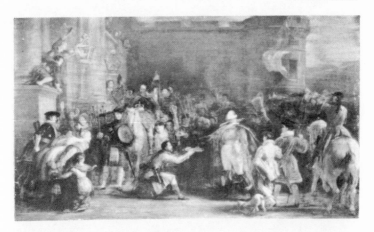

42. DAVID WILKIE : *William IV at Edinburgh*

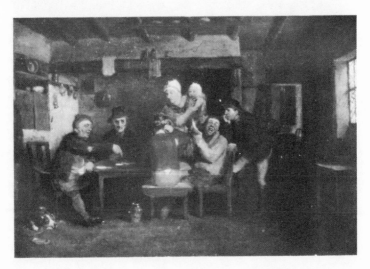

43. DAVID WILKIE : *Card-players*

PLATE XXVI

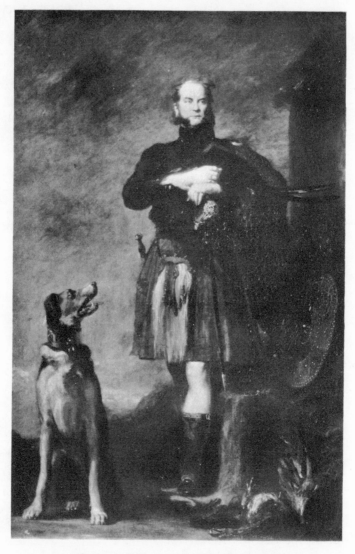

44. DAVID WILKIE : *The Duke of Sussex*
The Royal Collection, Buckingham Palace
By Gracious Permission of His Majesty The King

too prominent. In that, he is never vulgarly senti-
mental, but his desire to make the point of his anec-
dote is too evident and leads him to sacrifice too
much to it. In this respect perhaps Wilkie is more
responsible than anyone for much future disaster
to our art. The fact that he told stories in paint
very well—you can see how well in the *Blind Man's
Buff* at Burlington House, endeared him, through
his prints, to a large unsophisticated public, a
public that had no interest in his art. At the same
time he was a genuine artist, and was rightly
esteemed as such by those who understood that
side of his work. But he gradually put more and
more weight on the anecdote and less and less on
his design, so that he helped to start British art on
that facile descent into Avernus which led to, let
us say, Marcus Stone and Briton Riviere.

But in some of his designs (*Fig. 43*) we have no-
thing to complain of; the story interferes no more
with the design than it does in Ostade. The com-
position is full of interest and significance, the
figures are grouped with a fine sense of placing,
and their relation to the space is perfectly felt.
That he could not have done it without his study
of the Dutch is perfectly true, but it is none the less
a very happy discovery in design.

And while we are on this question of his com-
position, look at the sketch done, I suppose, for a
big commemoration picture of *William IV receiving*

the Keys of Edinburgh Castle (*Fig. 42*). It is a very beautifully organized design, with its broad management of the main masses of light and shade, its ingenious balance of directions and its perfect spacing. We ought at this moment to have had a great romantic art based on Rubens, for Delacroix, who realized that conception, never made so happy a discovery in that vein as this.

I only know the portrait of *Lord Kellie* (*Fig. 45*) from photographs, but it is of great interest because it suggests something which might indicate an effort in a new direction, towards an altogether richer, denser kind of painting and a more searching understanding of form. Was it only a technical experiment or a sign that if Wilkie had lived something much bigger might have come out of him? Anyhow, it is a very moving portrait, not quite in key with the ordinary sentiment of the time.

Wilkie's extraordinary competence both in design and execution is most clearly demonstrated in his life-size portrait of the *Duke of Sussex* (*Fig. 44*) at Buckingham Palace. There are not many portraits of the eighteenth century that surpass this for sheer mastery and painter-like quality. There is, of course, a hint of the curious bad taste of the time in the sharpness and thinness of the accents here and there, and something a little overconscious in the pose, but no one could have designed

and modelled the hands more finely or composed the light and shade more broadly. In tone and colour it holds admirably throughout and the composition is perfectly balanced by a most ingenious use of the rather difficult motive of the dog, which might quite well have upset everything, if Wilkie had not known how to keep the exact proportions of his picture space. It is tragic to think that the man who did this did not leave us more masterpieces.

There is a little landscape drawing which is just another indication of what possibilities there were in Wilkie. It is so beautifully composed, so sensitive and discreet, and so free from the sentimentality of the romantic landscape of the day.

One of the great surprises of the Exhibition were the three portraits by Geddes, Wilkie's compatriot. I had for long admired the portrait of his mother in the National Gallery of Edinburgh, but the other two were less known. Both of these showed an acute sense of form with a sharp incisive touch—the portrait of *Sir Walter Scott* throwing the rather superficial portrait of him by Lawrence in the shade. But one would need to know more of his work than these to get a clear idea of his artistic personality. I hope someone will take up the subject and make him better known.

99

Leaving the landscape painters to be dealt with later, I will continue the figure painters in chronological order. The next is Bonington, the first of our artists to be born in the nineteenth century. He was, of course, also a landscape painter, but his kinship is closer with the group we have been discussing.

In that extraordinary constellation of talents that marks British art at the beginning of the nineteenth century Bonington appears with the brilliance and brevity of a comet. He only lived twenty-six years, from 1802 to 1828, but his precocity and productivity were so great that his pictures are not very rare. When one thinks how unusual it is for an artist to have achieved anything by the age of twenty-five, one must suppose his native gift to have been one of the most extraordinary ever seen. It seems as though there was nothing he might not have accomplished.

At one time Bonington was regarded as belonging to the French school, but we seem to have recaptured him, though with scarcely more reason than we might have for claiming Sisley, for, except for a few visits to England, his whole life from about sixteen was spent in France. It is true that at the beginning of his stay in France he had lessons in water-colour from Francia, a pupil of Girtin's, but

PLATE XXVII

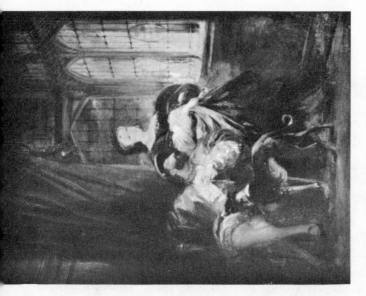

46. RICHARD PARKES BONINGTON :
Francis I and Marguerite de Navarre
Wallace Collection

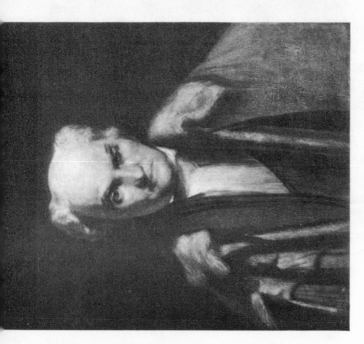

45. DAVID WILKIE : *Lord Kellie*
Lille Museum

PLATE XXVIII

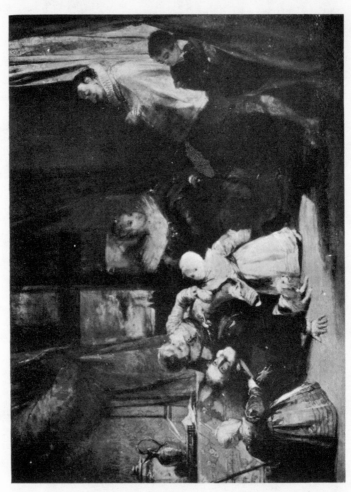

47. RICHARD PARKES BONINGTON : *Henry IV and the Spanish Ambassador*
Wallace Collection

he learned his art in Baron Gros' studio, and still more by studying in the Louvre. He was the intimate friend of Delacroix, living at one time in his studio, and the question of which was the inspirer and which the inspired is not easily settled. That Bonington had a greater native gift I can scarcely doubt, but undoubtedly Delacroix had painted some of his large and important compositions before Bonington had attempted anything but small canvases. But these small pictures, especially the three in the Wallace Collection which belong to his last years are all of them extraordinary works.

In his *Henri III and the English Ambassador* the design and composition is brilliantly found. Only a man of great sensitivity to that would have had the idea of broadening the group of the ambassador, which receives a strong light by placing the light of the window behind. By this means he spares the strongest accent of contrast for the figure of Henri III. There is perhaps a tendency to too brilliant and sharp accents in the detail of the furniture and bric-à-brac, which gives a slightly theatrical note. But this, which is just as evident in Delacroix, seems to have been inherent in the taste of the time. But the figures are astonishingly right not only in movement and fullness of relief, but also if judged from a psychological point of view. If it is theatrical the actors are playing their rôles to perfection.

The portrait of *Francis I and Marguerite de Navarre* (*Fig. 46*) is even finer in the ease and breadth of its illumination—and how rhythmically the lines of the two figures are interwoven to build up a single group with the most vivid suggestion of its recession. Bonington here has realized the great principle of Rubens's design as Delacroix, with his halting rhythms, never could. If only some of the accents had been less sharp, if only he had understood more clearly the restraint of Rubens, even at his most brilliant!

The third composition at Hertford House, of the *Spanish Ambassador coming in on Henri IV while playing with his Children*, is another delightful discovery in design. It shows Bonington's rare understanding of how to obtain breadth by the way he has put the strongly lit group of the King and his children against a lighted part of the room. He attains perfect clarity without cutting contrasts and violent oppositions.

Bonington used to lament to Delacroix that he had not managed to do any large-scale compositions, but those who saw these minute pictures enlarged on the screen to monumental dimensions were able to see that there was nothing to prevent him from attempting the biggest schemes. The enlargement revealed no weaknesses in proportion or construction. There is no question in these pictures of any sacrifice to story-telling—such as

we saw in Hogarth—the subject is taken for the opportunities of pictorial design it affords. The design crystallizes round the theme in the artist's mind just as in the great masterpieces of the Renaissance. The gifts required for such works as these are of the rarest and highest kind, and that a man under twenty-six should have attained to such pictorial science as this is almost unheard of.

Bonington had then the gift of happy invention to a high degree and apparently the understanding of how to give it the fullest expression. Nor is his reaction to the thing seen less remarkable, as you can tell by his *Portrait of a Young Man in a Top Hat (Fig. 48)*. With what a nice sense of proportion he has placed the figure in the picture space, and how subtle, and yet frank, is the statement. It is extraordinary what relief Bonington gives to the head within the very narrow range of tone which was all he could afford if he was to get the full shock of the almost brutal contrast of the top-hat. And even that delicately modelled face has to be brought out against a sky of almost the same tone. But the feat is accomplished with such ease that we scarcely notice it. This picture seems to be an anticipation of Manet in the frankness and directness of its oppositions. It should have been the starting-point for a great tradition of nineteenth-century art. But we look in vain for any successors.

And Bonington handles landscape with the same consummate ease and mastery. How spontaneous and original is the placing in the picture (*Fig. 50*), with its easy grasp of a wide angle of vision; how vital and stimulating is the touch; how clearly all the movements of the terrain are understood, and how precisely right is the sharp accent made by the cows, just at the point where it acts like a keystone to the whole structure.

But even here there are disquieting signs. The trees have those sudden sharpnesses and thinnesses of accent—they are too elegantly feathery, they have not their proper volume and density—and the relation with the sky is uncertain. This flimsiness —far less evident here than in many of his landscapes—this emphasis on the feathery airiness of foliage comes, one suspects, from the same kind of sentimental falsity as we saw in Lawrence's women. They are bad signs for the future. Perhaps Bonington's far robuster figure design would have saved him; who knows?

Still more in his marines we get what is typical of the new shift of taste as it affected landscape— there is a want of density and resistance in the tones, nothing is felt in its substance, so that the recession of the shore is not fully expressed. There is a sacrifice of all the connecting transitions in order to increase the delicate sharp accents. It is the beginning of a special conception of the pic-

turesque, a pretence that everything is airy and ethereal.

But in his *Versailles* (*Fig. 49*) Bonington seems to have recovered himself. It has a fine robustness and vigour with its blunt oppositions of tone. Here again, as in the portrait, we can think of Manet. Here the ground is solid enough, the trees have their bulk and only the sky is still wanting in continuous structure.

I will speak here of one other figure painter, Etty, who, though born long before Bonington, worked on right into the middle of the nineteenth century. He was a pupil of Lawrence, and learned something of his firm draughtsmanship, so that he became one of the few artists of the nineteenth century who showed mastery even in the drawing of the nude. The absence of nude pictures except for a few Etty's at Burlington House is, by the way, one of those curious indications of the slack temper of British art as a whole of which I spoke before. No doubt our Puritan prudery is responsible for much, but I think it is quite as much due to that absence of a passionate interest in plastic form which has always tended to affect our art.

But some of Etty's nude studies show real mastery and such a delicacy and solidity in the

modelling as promised the possibilities of great figure design.

Unfortunately he seems to have had no very positive or personal imaginative attitude. He could paint nudes, but he did not know what to do with his figures. In his Diploma picture we see him ingeniously fitting together a *pastiche* of a Poussinesque design with a careful and brilliant study of a nude model, but the two elements do not fuse. His nude refuses to become a nymph, and his satyrs remain mythological and are left in a different world.

Etty marks for us the terrible descent in Victorianism of which I have spoken. There is a head of a woman by him at Burlington House of which I could not get a reproduction. It is curiously like a Delacroix, only it is almost more strongly painted than Delacroix could have done it, and yet Delacroix kept his creative energy alive right on into the mid-century, never relapsing from his high ideal of imaginative art.

From his nude or from that strikingly painted head we might have concluded that Etty was the man who, failing Bonington, had the power to give us a great school of romantic painting, for which, after all, the English temperament seems more naturally adapted than the French. Yet if we turn to such later works as the *Aurora and Zephyr*, or his *Youth at the Prow and Pleasure at the Helm*, of

the National Gallery, we see the most disastrous decline. What, one wonders, can have reduced the romanticism of the 1820's, even if we admit its taint of theatricality to this. What has brought a man like Etty to the level of this insipid and puerile stuff? A mawkish sentimental drivel is all that remains of our imaginative invention. Sir Noel Paton and Dicky Doyle are all that we can show. And Etty, with the gifts of a real painter, has nothing better to occupy him.

And under the influence of that sentimentality Etty loses all his qualities as a painter. There is no consistency either in tone or colour; everything has become slimy and slippery and without body.[1]

Before turning to the landscape painters it may be as well to carry on this side of our art to the end of our period—till about 1860, that is.

With this decay of all standards of art, when only lip-service was paid to the good sense of Reynolds's Discourses, the ground was prepared for two monstrous and complementary growths. On the one hand there crystallized out the commercial painting of the Royal Academy, moulded to suit the taste of the new-rich Philistine, and, on the

[1] Perhaps we must reckon *Alice in Wonderland* and *The Rose and the Ring* as the only jewels that we have picked out of that mud.

other hand, in protest to that, a whimsical æstheticism utterly divorced from life and from good sense. We were ready to fall victims to the crazy pretensions of the Gothic revival. Although this had started from a genuine though uncritical passion for mediæval art, it was by now being exploited by enterprising architects, whose 'lawless and incertain' fancies were realized at vast cost in all-too-solid bricks and stones all over the country, thereby destroying for a long time to come all possibilities of a reasonable architecture.

And when, about 1850, a small group of artists, the Pre-Raphaelites, realized that the art of painting might be something more than a gentlemanly trade, that it might have spiritual significance, and devoted themselves to it with disinterested passion, ideas about art had become so utterly confused, there was such an absence of any traditional standard, that they could not think out their problem clearly; they fled from contemporary life instead of facing and interpreting it; they built an artificial shelter from the Philistine blizzard out of half-apprehended mediæval notions and archaistic bric-à-brac; so that all their passion and their heroism could not really rekindle the flame of inspiration. It had no roots in life—it was an artificial hot-house growth. They had shut themselves off from new experiences, and so starved their own imaginative life.

PLATE XXIX

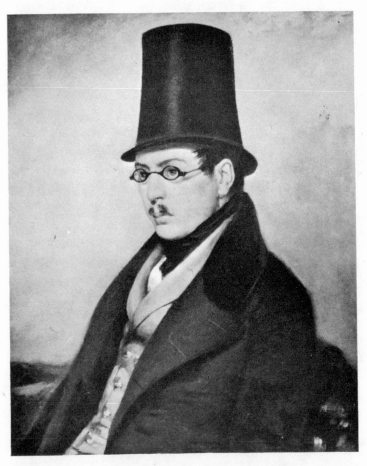

48. RICHARD PARKES BONINGTON: *The Man in the Top Hat*

P. M. Turner Collection

PLATE XXX

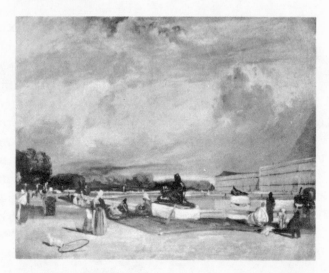

49. RICHARD PARKES BONINGTON : *Versailles*
Louvre

50. RICHARD PARKES BONINGTON :
The Sunken Road
P. M. Turner Collection

PRE-RAPHAELITES

To give any sort of explanation of the strange phenomenon of Pre-Raphaelitism would require a separate study. The room devoted to them makes a strange and sudden irruption into the general tenor of the exhibition. Whatever, one wonders, induced men to paint such crude local colours in such flat, inexpressive pigment? None of the artists who came before Raphael, whether in Italy or in Flanders, would have tolerated such crudities, none of them achieved this grotesque discordance of one part with another, none of them but gave a little more body and solidity to their figures. One has to put oneself back into the past to understand them at all; one has to look at Frith's *Paddington Station*—in order to realize what an artistic Sodom and Gomorrah it was from which they fled in such precipitate haste that they seem to have brought nothing with them. To save their souls by escaping at all costs, that was the pressing need—to escape from the hideous present, and whither?—nothing offered itself but the past, a dimly guessed-at past, a past they did not know much about, and that they had not the critical sense to understand. The past has now and again been the key to the future—it had been so in the Italian Renaissance—it might be so again. And it was the way the Gothic revival had

taken—though that, one would think, might have been a warning. But, anyhow, for a moment that escape gave them a new faith, a new hope and a new energy. It was worth while to make a tremendous effort, to take one's work seriously; and the passionate conviction of Rossetti inflamed them all. And so there is Millais' *Lorenzo and Isabella*, which is one of the few ambitious figure designs in the Exhibition—the only attempt at a complicated figure design. It was a work which strained every nerve and muscle of the artist. It is in striking contrast to the general complacency and caution which is so depressing a feature. There is something heroic in it. It is, of course, a heroic failure. The linear design is original, sincerely felt and worked out with extraordinary determination, but the tones and colours are all over the place—nothing holds in its plane, nothing exists, except on the flat map of the linear pattern. If Millais had only understood Duccio—and he could hardly go much further back—he might have learned that even flat colours must conform to some conception of their position in the picture space.

Still, there it remains, a pathetic monument of a heroic adventure that failed because it was based on misunderstanding and could draw upon no fresh sources of inspiration from life. Millais himself quickly drifted away and wasted his great

gifts on vulgar inanities, and English art had to await the reflux of Constable's impulse as it returned to us, belated and already rather exhausted, from France.

The notion which was common in my youth that Wordsworth was the first to draw us to enjoy the beauties of nature is one of the strangest of legends. Probably no people, however primitive, are altogether insensitive to the changes of mood which nature imposes on us by the mere shift of storm and clear skies and the alternations of light and dark. None, therefore, are without the sentiment which leads to a landscape art. None the less the change in men's sentimental attitude which took place in the eighteenth century, and led ultimately to the Romantic movement, did imply a stronger focussing of attention on these reactions to nature. It also changed people's taste in landscape, and made them prefer the wild to the cultivated, the mountain to the plain and the torrent to the river. This change is ascribed to the growth of a romantic feeling for landscape, but that does not express the whole truth, since Wilson's and Cozens's classic landscapes were already conceived from an essentially romantic point of view.

The love of landscape, then, I believe to be universal, but none the less the Englishman's attachment to country life and his love of nature is peculiarly strong, and also, I think, he is peculiarly conscious of this feeling, and therefore delights in giving it expression or having it expressed for him. Thus it came about that with the stirrings of that new, more intense interest in wild nature, which marked the turn of the century, England produced a quite extraordinary number of highly gifted landscape painters.

It is curious to note how nearly contemporary almost all our great landscape painters were. Crome, Constable, Turner, Girtin, were all born within eight years of one another, from 1768 to 1775, Cotman, de Wint and Cox in the next decade, and Bonington in 1802; and I have not mentioned a whole host of others, like Holland, Varley, Prout. Some very powerful influence must have been at work to turn all these men to landscape. The preceding age had been much interested in topography, in views of distant countries, but with this generation there is a change of focus—landscape becomes the expression of poetical mood and not a mere curiosity, carrying on in this respect Wilson's example.

PLATE XXXI

52. JOHN CROME : *Watercolour*
Victoria and Albert Museum

51. JOHN CROME : *Landscape*
P. M. Turner Collection

PLATE XXXII

53. JOHN CROME : *New Mills*
Dyson Perrins Collection

54. JOHN CROME : *Mousehold Heath*
Victoria and Albert Museum

CROME

And Crome, the earliest of this group, formed
himself so closely on Wilson that some of his earliest
works still pass under Wilson's name. Gains-
borough also he studied, but the determining in-
fluence came when, about his twentieth year, he
had access to the Hobbemas, Ruysdaels and
Wynants of a Norwich collector. He turned at once
to them, and the Crome that we know is the out-
come of that influence. Indeed, he entered more
deeply into the spirit of Dutch landscape than any
other British painter, though he gave to their for-
mula a distinctively English sentiment and a per-
sonal colour scheme.

Let me remind you here of what I said in speak-
ing of Gainsborough about the relative influence
of Italian and Dutch landscape on English artists—
how little the study of Italian models availed to
give them the principles of Italian art, and how
much more easily they understood spatial plastic
design as exemplified by the Dutch.

The same effect is evident in Crome's work.
And, like Gainsborough, he first learned from the
Dutch how to construct a consistent spatial design,
how to give recession, not by a mere succession of
flat layers, but by continuous transitions of plane.
He developed a three-dimensional imagination—
but only to a certain extent; he never attained to

the full control we find in Gainsborough, and shall later on in Constable, and there always remained in him a trace of conflict between his organization of the flat surface—his flat pattern—and his solid pattern. But this, it so happens, is one of the elements of his peculiar charm.

In his painting of *New Mills* (*Fig. 53*) the spatial design is strongly imposed by the receding diagonal of the river, further emphasized by the sequence of buildings, broken by alternate lighted and shaded planes, which enable us to realize it vividly. And here Crome has been happy in harmonizing so completely this solid pattern with the flat pattern made by the tree mass in the centre, which itself counts both as mass and silhouette. All these are beautifully related in their proportionate quantities. A warm silvery light envelops the whole of this beautiful effect.

In a *Landscape* (*Fig. 51*) Crome shows a fine feeling for the whole spatial effect. The essence of the design is the placing of the tree, which rises so freely into the wide encircling space of air. Again we note the exquisite taste in the choice of proportion of volume to the space it fills, and no less the delicate pattern made by its silhouette.

It is, of course, very near in feeling to certain Dutch landscapes. Perhaps Ruysdael would have constructed the terrain more solidly, would have given us a stronger sense of the receding planes of

the slope to the right with more of density and solidity of texture, but he would hardly have accepted a theme with so little incident or have given such glow to the atmosphere.

In the *Poringland Oak* of the National Gallery this atmospheric quality is supremely realized. In that his interest in the intricate play of the interlacing branches and foliage, exquisitely rendered though it is, somewhat confuses the design, but again we get Crome's rare beauty of pattern in the double systems of the foliage and the clouds.

The Postwick Grove (Fig. 55) is in the nature of a sketch. It is rendered with delightful freedom and spontaneity. It is almost as direct in its approach, and almost as naturalistic in colour, as a Constable or a Corot.

In all the pictures of Crome which we have discussed there is no tendency to emphasize in any way the poetical overtones. He leaves his impressions of nature to speak for themselves. In this he is more classic than Wilson or Turner. But there is another group of pictures by Crome of which this is no longer true. Every now and then he seems to have made an effort to meet the demand for poetical landscape and painted pictures of moonrise seen either through a wood or across the flat river valley of the Yare, with the sails of barges making impressive silhouettes against the moonlit sky. Now these effects even in nature tend to

suppress both space and volume, although in actual life we build up some conception of these from almost imperceptible changes of tone. But in painting it is extremely difficult to convey these. I do not know of any artist except Rubens who has succeeded in basing a coherent and solid pictorial design upon such effects, and certainly Crome's rather hesitating grasp of construction was unequal to the task. Nor is the flat patterned effect rich enough to compensate for this. The result is that these pictures have little power to hold our attention after the first shock of recognition of an effect which no doubt has its romantic appeal.

Perhaps in landscape art we ought to recognize that there are two alternative methods which appeal to two different classes of people. A great number of those effects which in nature appeal most to the average sensitive person, which we may roughly call poetical—such effects as those of moonlight and mist—are those in which plastic form is more or less suppressed, leaving little but the patterned silhouette. A great deal of the landscape art of China and Japan is based precisely on the poetical evocations of such motives, and English landscape has often tended in the same direction.

Such a landscape art is clearly more allied to literature than, let us say, the landscape of Rubens. For it depends mainly on the associated ideas of

PLATE XXXIII

56. JOHN SELL COTMAN : *The Waterfall*
R. J. Colman Collection

55. JOHN CROME : *Postwick Grove*
R. J. Colman Collection

PLATE XXXIV

57. THOMAS GIRTIN : *The Louvre*
British Museum

58. THOMAS GIRTIN : *View of London*
British Museum

the things represented, although it has no doubt visual form insofar as the proportions and dispositions of the flat pattern are concerned.

It is perhaps mainly because the formal relations which such effects allow are so limited—we read so quickly all that the design contains—that those who have once acquired the feeling for plastic design are impatient of such an art. It fails to give them that illusion of an infinity of possible new revelations of formal harmonies in which they find their greatest pleasure.

In this respect Crome is particularly interesting to study by reason of his rather ambiguous attitude. He is not without plastic imagination, but it is often rather feebly expressed. Thus in his celebrated *Slate Quarries* (Tate Gallery) our first impression of the mountain mass is not clearly sustained, and we have to fall back on the charming intricacies of its surface patterning and the distinction of its essentially decorative colour; for here too there is no attempt to express the colour changes due to plastic movement.

The same is true of the *Mousehold Heath* (*Fig. 54*). Although there is a general suggestion of the modulations of the terrain and its recession into the distance, we have only to look at a Ruysdael or Hobbema to see how relatively feeble is Crome's imaginative grasp of these elements. In compensation we have a lovely flat pattern made by the patches of

grass on the sandy soil, by the flat silhouettes of the sheep and the strong accent of the shepherd boy—this last, I think, not perfectly happy in its placing.

But it is in his watercolours (*Fig. 52*), perhaps, that the peculiar distinction and taste of Crome's art comes out most clearly. He seems to me one of the best of all our water-colour artists in the variety, richness and delicacy of his contrasted silhouettes and the choiceness of his colour. He is in these respects the most Chinese of our painters.

The enthusiasts for the Norwich school are divided upon the question of whether Crome or Cotman was the greater artist. Cotman, I think, is regarded as more refined and his cult as more esoteric and select. I fear I must come in on the side of the vulgar, for I think Cotman's a very overrated reputation. Unlike Crome, he was, I think, the slave of his water-colour technique, instead of its master. Water-colour is an excellent medium if it is used as the old masters did for making rapid notes of light and shade with perhaps a few suggestions of colour, but when it is used for a finished picture the artist is in a dilemma—either he must express his vision in all its fullness and solidity, in which case he must sacrifice beauty and freshness of quality, or he must choose to state just

so much of his vision as can be adapted to those untouched flat washes on the paper which alone give the full charm of the medium. Cotman was a master of this art, and, one imagines, an almost ideal teacher of it. Indeed, almost all his pictures look as though they might have been planned for the pupil to copy, so skilfully has he found conventions for tree masses, for sky and water, of such elementary simplicity that they can be stated without difficulty in that exacting medium. His flat washes are disposed in admirably decorative silhouettes, and he chose his scenes with a nice sense of their dramatic appeal, so that they would make almost ideal theatrical backgrounds; and yet they are stated with such discretion and reserve that it seems blasphemous to use the word theatrical in connection with them. And yet I can find nothing else there, nothing has any depth or body or solidity—it is all reduced to a formula—there are neither volumes, nor spaces, nor light, nor air— only decorative substitutes for these.

The Waterfall (Fig. 56) is one of Cotman's most striking designs. It is an oil painting, but this makes little difference, for Cotman was so enamoured of the method he had devised for water-colour that he generally uses oils in the same flat, extremely simplified masses juxtaposed with a strikingly decorative effect. It is undoubtedly a bold and striking scenic effect.

Now and then in his oil paintings Cotman aimed at a richer, more complex effect in order to express the multiplicity and agitation of foliage. But always he is the slave of his medium, always he will risk nothing that might imperil the charm and decorative amenity of his surface, and for that end, too, colour must be kept in a narrow range of safe and irreproachable harmonies. And nearly always it is only scenic effectiveness that he looks for in nature, although the obviousness and vulgarity of that reaction is covered up with so much taste and such an air of almost archaic austerity that I recognize how scandalous such a criticism must sound. It is essentially the same thing with Cotman as with some of our modern archaistic sculpture which finds such a warm welcome from a certain type of cultured people who fail to see its underlying sentimental vulgarity.

And now, since I may as well be hung for a sheep as a lamb, I should like to say a few, no less heretical, words in defence of a much despised artist, David Cox. Cox seems to us so eminently Victorian that we tend to forget that he was the exact contemporary of Cotman—so Victorian that he has for long been the butt of people of taste. 'That dobber', Whistler used to call him in con-

tempt for his agitated handling, but then Whistler himself was one of the most conspicuous victims of our national mania for beautiful surface quality, and it is just because Cox was sufficiently excited about certain emotions which he felt before a wind-blown, cloudy sky seen across a wide expanse to let his drawing go hang in his desire to get something of that expressed, that he seems to me still worth looking at. His was neither an original nor profound nature, but he worked with passion and cared more for his idea than his picture. Once at least in his sketch of *Rhyll Sands* his passion for seeing led him to a bold venture, right outside the conventions of his day and prophetic of a quite modern outlook—modern enough for it to resemble some of Whistler's own followers. But generally his vision, though it was that of a genuine artist, was so near to a rather commonplace attitude that he found his public among quite unsophisticated lovers of nature, and was even, I believe, a favourite of Queen Victoria. The drawing belonging to Sir Robert Witt (*Fig. 33*) shows the Queen driving in Windsor Park. It is some satisfaction to me that, in spite of my heresies about British art, I can for once shelter beneath so august an authority.

Since Cotman belonged to the same Norwich school as Crome I treated them together: but in chronological order Girtin should come before Cotman. Girtin died at the age of twenty-seven. His loss to our art was a serious one because, in his short life, he gave promise of the highest and rarest artistic qualities. Neither from Dayes, his master, nor from Cozens, whom he copied, could he have learned his profound feeling for plastic design and construction.

At first sight there does not seem to be very much difference between Girtin's landscapes and those of his contemporaries, since he usually chose the same kind of romantic and dramatic effects that they did; only, unlike them, he sacrifices nothing to effect. He carries a solid and consistent construction through every part. His designs have a fullness of substance, a resistance and weight that are peculiar to him, and this quality became most evident in his latest Paris sketches, where the romantic emphasis is very slight and his designs have the clarity and spaciousness of Canalettos.

And his sensibility was alert to new and unexpected impressions; he did not have to wait for romantic or dramatic situations to turn up, as most of his contemporaries did. In his *View of London (Fig. 58)* there was nothing to suggest the

making of a picture, but Girtin has seen its strange possibilities. To him the significance of the grey glitter on slate roofs was just as great as the play of light on a mountain tarn. He belongs by sheer native genius to the great tradition.

And see what a new value he has discovered in his drawing of *The Louvre* (*Fig. 57*) by this disposition of his space. How little he cares for the picturesque, how much for the universal and fundamental meanings of our physical situation in a spatial world. I sometimes think that painting is as much based on giving us the orientation of our spirits in space as music is of our orientation in time. Here at least is a new revelation of what that may mean.

Difficult as it is for me to speak of Cotman, it is nothing to my hesitation in approaching Turner, for in a sense Turner is sacred. For some strange reasons this Cockney barber's son, whose life was neither edifying nor dignified, has become a kind of national hero, has come to stand as a symbol for things that, on the face of it, have nothing to do with him or his art. As I said, he was one of the great influences on my youth, and through that I ought to be able to understand what this feeling is. What I then liked and almost worshipped were

those late watercolours, all mist and mystery, with a blue crag looming up here and a splash of lemon yellow and rose there. And what I found in them was an outlet for the vague aspirations and yearnings and half-understood desires of youth. Turner was a splendid sounding-board for the murmurings of my own spirit within me. He was all the more useful to me because he did not communicate any definite experience to me. He did just enough to start trains of reverie within me.

But as we grow older and cease to be the astonished spectators of the unfolding of our own spirit, we go to art for what it brings to us from outside, what it will add to our life by its definite communications, by giving us feelings which we have never had and never could have but for the artist. We want something added to us, not something that will release what is already there. That at least is the best I can do to explain why I am no longer able to respond to Turner's magic appeal.

I see that among recent books on British Art which the prospect of this Exhibition has called into being there is an almost universal consensus of opinion that Turner is the greatest landscape painter that ever lived. That is a large order and, alas, I cannot subscribe to it. Let me admit that he was a man of dazzling genius, and even more than that, a man of staggering dexterity and adroitness. He is an unparalleled conjurer with paint, and

PLATE XXXV

59. JOHN CONSTABLE : *Stoke-by-Nayland*
Victoria and Albert Museum

60. J. M. W. TURNER : *Battle of Fort Rock*
P. M. Turner Collection

PLATE XXXVI

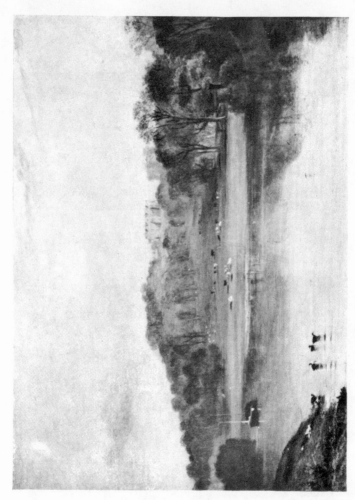

61. J. M. W. TURNER : *Somer Hill, Tonbridge*
National Gallery of Scotland, Edinburgh

there is nothing he cannot bring out of the hat or make us believe that he has. There is nothing that others had done that he could not learn to do so as to make it look as though he had done it much better. He could take Claude's discovery of a certain aspect of nature and repeat it so that beside him Claude looks like a dullard and a duffer, and it takes one years to find out how much more Claude had felt and understood than Turner. He could paint a sea-piece in van der Velde's manner and in direct rivalry with him—as you may see at Bridgewater House—and at first glance he makes van der Velde look dull, matter-of-fact, plodding stuff. Now van der Velde was no tremendous genius, but when you have penetrated through the rather forbidding envelope of his surface you can feel your way about among his clouds and across his grey expanses of water with a certain exhilaration. Everything there has been felt and grasped by the artist—he has had a quite real and personal experience which he has expressed in a straightforward but not very exciting way, while, when you turn back to the Turner you will feel that he has not had any personal experience at all—he has only seen where, with his superior dexterity, he could restate van der Velde's idea in a more striking and attractive way.

Indeed, I wonder whether Turner ever did have any distinctive personal experience before nature,

He seems to me to have had so intense a desire to create, to do, to be busy about picture-making that he never had the time for that.

I do not mean that he did not look at nature; no one ever did so more assiduously or saw so many things with acute observation. He drew and studied incessantly, and he had filled his mind with a vast repertory of precise images. He knew more than anyone. He knew how a wave curled, how the spring of a branch of an elm differed from that of an ash, how a tree roots itself in the ground, what all kinds of cloud and rock form are like.

But he had looked at all this, had collected it all, in a practical spirit. These images were his stock-in-trade and his tools. He knew that any fact about the look of things might come in useful in his business at any time. They were essential to the business of making pictures, and that was his passion, to make pictures, and to make them superlatively well, and, incidentally, to beat others at the job.

His saying about Girtin is very significant of this attitude: 'If Tom Girtin had lived I should have starved.' It reflects his idea that art is a competitive game played in deadly earnest. But what, you will say, do you want more of an artist than that he should have a passion for making pictures, and making them well? My answer depends on recognizing that the urge towards the making of a work of art has two sources in our nature. One un-

doubtedly is the instinct to make things, to impress one's personality on the outside world by fashioning things to a desired shape. The other source is much more akin to our desire to understand the outside world. It arises whenever some emotional experience forces us to a disinterested attention to it, so that we want to find out for ourselves exactly all its significance for us, all its implications. This is typical of most great artists. Certain visual experiences compel them to this detached, contemplative attitude, and the work of art comes as the expression of that newly discovered significance. When we come to Constable we shall see that his work is full of such discoveries of significant moments in his visual life. But as far as I can see, Turner never had time for such contemplative receptivity; he was too active, too busy making pictures or collecting materials for pictures for that.

In most artists we find these two impulses present in various degrees, and sometimes they vary in relative intensity at different periods. Titian, for instance, began rather as a maker, and only became a seer later on, but in Turner the contemplative impulse was, I think, almost in abeyance. He never saw things with a really disinterested passion. His vision was a means to his ends, to this business of making pictures. And he was so immensely accomplished, he had such an enormous

repertory of pictorial receipts, that the first glance at a scene would give him the hint for an effective picture.

Perhaps the growth of romantic feeling about nature which Byron and Scott had imposed on the world suited his genius to perfection. The outline of a rock-perched castle against a misty sky, the glow of a sunset across an expanse of water, all those vividly dramatic and theatrical effects which artists had hitherto shunned, were by now eagerly enjoyed, and Turner had in his repertory all the pictorial devices for giving to such effects their full romantic appeal. He knew how to pick out and underline the exciting passages and how to pass over the rest a vaporous vagueness which stimulated the feelings by its mysterious promises.

Even from his earliest drawings we can get a measure of Turner's executive ability. Drawings of our Gothic cathedrals were much in fashion. It was the first time that people had looked at them with sufficient care to demand something more accurate than the vague formulæ which had done duty for Gothic in the eighteenth century, and which survives even in Canaletto's English paintings. Now it is an exacting task for the draughtsman to keep his sense of proportion and his feeling for the building as a whole amid the distracting details of Gothic mouldings and ornament. And in this Turner surpassed all his rivals—even

Girtin is not so light in touch, so elegant and free, though he gives something more important which Turner missed.

And he mastered no less easily in his early water-colours the most elusive and difficult appearances —the shapes of water falling in cascades—and no one perhaps ever gave more exactly than he did the swelling surge and pressure of water in a heaving sea.

It is part of the charm of these early drawings that they are so direct and straightforward. He was as yet too intent on learning his job perfectly to insist on its dramatic effectiveness.

But in such an early oil painting as *The Battle of Fort Rock* (*Fig. 60*) he has begun to show which way his ambitions lay. Here we can see that he had already acquired a wonderful facility for composition, and he has invented a very striking design. In this the blasted tree—itself perhaps a bid for James Ward's peculiar quality of paint— makes a wonderfully effective centre and sets the key to the whole design—and then he has woven together into one system all manner of exciting and moving motives—the ravine cut in an up-land plateau, across which we look to the slopes of distant mountains, the leaning pine tree to the right, the narrow broken bridge where the fight goes on. These are all motives that would bring us to a stand with a kind of gasp of wonder when

we are on our travels—they are the very essence of our vague romantic feelings before nature; but Turner has not probed further than that first gasp of wonder. That is what he counts on.

In his early years Turner's romantic feeling was still mainly of the classical kind—he drew its motives from Claude and Poussin as Wilson and Cozens had done. Only Turner could use his borrowings to much greater effect. His *Bonneville* is one of the finest of these, and is, I confess, a most impressive picture. Every time I see it I have an instinctive response of delight. It is all so happily put together—that receding road invites one so delightfully into the distances—the mountains build up in such lovely sequences, and the cumulus cloud gives so right an answer to their inclination. Surely this is a masterpiece. Yes, of course, in a sense. But it is, after all, only Poussin at second hand, Poussin done with much more detailed observation, and also Poussin filtered so as to strain off the cream of whatever in him makes that direct romantic appeal. There is no sign of Turner's own specific vision, his own discovery. It is no use to dig for that—all is given in the first shock.

Let us pause for a moment to see what he did with Claude. Before such a work as his *Crossing the Brook*, in the National Gallery, our first exclamation is, What calm, what vistas of sunlit plain and valley, and how lovely is the curling plume of the

pine tree overhead! The trouble begins as one looks into it, as one realizes that everything is twisted in a flattering direction—that glade, which you look down, has some exquisite false greens which do not come out of anything in nature, which do not belong to their surroundings —that distance is too packed with lovely incidents, like the tower on the bridge—the incidents for which we buy picture post cards. In short, it is too constantly picturesque, and these incidents do not occur as part of a plastic whole—they are picked out for us.

And then one turns to poor old, stupid Claude, for I maintain that he was a very slow-witted fellow and no match for that clever Londoner. But in his clumsy way how intimately he has felt everything; how real his tree masses are; how full of substance, how truthfully he has stuck to their monotonous grey greenness and found in that a rare colour scheme which satisfies us more when we have grasped it than Turner's flattering tints; how subtly and truly the colours are modified by the luminous haze through which we see them; and so, Claude lasts when Turner fades for us.

I know that in a sense all these comparisons are rather futile, but they may make one see specific qualities better, and, after all, Turner himself asked for the comparison.

I am glad, though, that Turner's *Somer Hill*
(*Fig. 61*) was at Burlington House because, more
almost than any other picture, it tends to revive
in me my ancient worship of Turner. It seems
more nearly a personal vision than any of the
earlier work, and it has not as yet the excesses of
his later. It has a breadth and suavity and an ease
of movement which are exhilarating, and though
there are some details which seem to have a merely
illustrative value, and although it is thin and un-
substantial in its modelling, it has an unusual free-
dom from the more obvious appeals.

In his later work Turner is undoubtedly original
and personal. Therein he achieved, under the in-
spiration of Byronic poetry, his own vision. But,
alas, his own vision is not nearly so interesting as
that which he once borrowed from Claude and
Poussin. In such pictures as the *Cicero at his Villa*,
which was at Burlington House, the canvas shows
a number of violent accents scattered here and
there over the surface, unrelated to each other
by any continuity of tone. They are moments of
romantic interest unsupported by any structural
unity.

Again, in his famous *Rain, Steam and Speed*, at the
National Gallery, nothing is left but the melo-
dramatic illustrational element. There is no longer
even the faintest pretence of pictorial design—the
dark mass of the viaduct at the lower right-hand

PLATE XXXVII

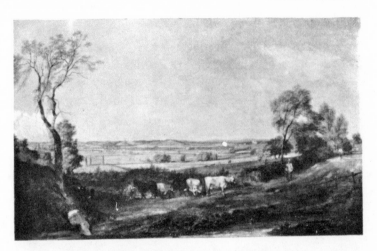

62. JOHN CONSTABLE : *Dedham*
Granville Proby Collection

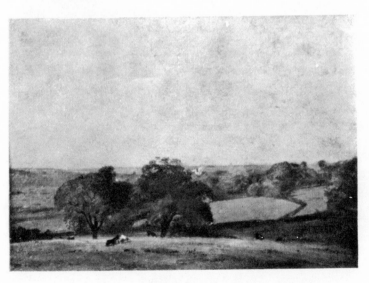

63. JOHN CONSTABLE : *Near Bergholt*
Sir Michael Sadler Collection

PLATE XXXVIII

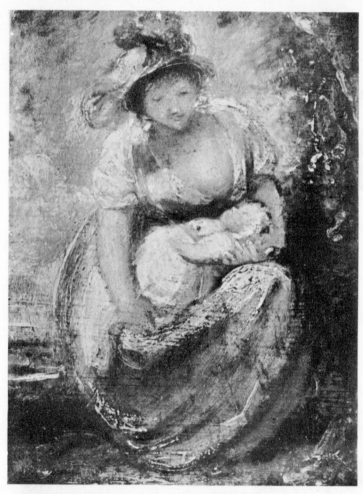

64. JOHN CONSTABLE : *Mother and Child*
P. M. Turner Collection

corner is left unbalanced by anything else in the picture. It is a surprising phenomenon in the work of a man who had shown in his youth such easy mastery of the principles of pictorial balance. Everything else is sacrificed by now to the collection of picturesque or romantic incidents marked by thin and exaggerated accents; there is no trace of the suave masses and harmonized silhouettes of his earlier work. He has become a sensationalist, an exhibition painter.

It is often alleged that the Impressionists owe much to him, and I believe some of the French masters of Impressionism accepted the claim. It is difficult to see on what grounds. The picture that is usually cited in evidence of this is the *Interior of Petworth* at the National Gallery. It is no doubt very sketchy and unfinished, and people are apt to call anything sketchy Impressionist. But there is no necessary connection between the two. Many Pissaros are more highly finished and more detailed than some of Titian's work, and artists of almost all periods have occasionally left a first statement untouched for what it was worth. But the *Petworth* contains no suggestion of the Impressionist principle of a consistent observation of the influence of different lights and of atmosphere on local colour. On the contrary, it is little else but local colour put on in vague splashes and dabs but not bound together by any such

consistent idea. No doubt also Turner in his later work painted largely in positive, brilliant colours, suppressing all the greys and degraded colours which tend to predominate in most natural effects; and here again there is a superficial likeness with those Impressionists like Monet who chose those moments in nature in which positive blues and roses occur. But Turner does not observe, as the Impressionists did, any consistent naturalistic principle in the relation of his vivid colours—such relations as there are being, as it were, self-determined without much reference to optical laws. This, of course, is no condemnation of Turner's practice, only it is, I think, a mistake to compare it with that of the Impressionists. In order to see those Impressionist principles fully applied we must turn to his great rival, Constable.

From one point of view the whole history of art may be summed up as the history of the gradual discovery of appearances. Primitive art starts, like that of children, with symbols of concepts. In a child's drawing of a face a circle symbolizes the mask, two dots the eyes, and two lines the nose and mouth. Gradually the symbolism approximates more and more to actual appearance, but the conceptual habits, necessary to life, make it very dif-

ficult, even for artists, to discover what things look
like to an unbiassed eye. Indeed, it has taken from
Neolithic times till the nineteenth century to per-
fect this discovery. European art from the time of
Giotto progressed more or less continuously in
this direction, in which the discovery of linear per-
spective marks an important stage, whilst the full
exploration of atmospheric colour and colour per-
spective had to await the work of the French Im-
pressionists. In that age-long process Constable
occupies an important place. He is thus the one
English artist who has added something to the
European idiom of painting. In that historical pic-
ture he occupies a place between the seventeenth-
century Dutch, who had contributed a great mass
of new material to our knowledge of appearance,
and the modern French—and, with the exception
of Chardin, he is, I think, the only artist in these
two centuries who made a distinct advance in the
discovery of appearance. It was, indeed, an im-
mense advance that Constable made, for, though
the principles of Impressionism are implicit in
many of the Dutch landscape painters, they
scarcely recognized them as such. For though these
Dutchmen, with their incredible alertness of eye,
recognized the changes in local colour due to
atmosphere and reflection, they always tended to
understate them. But with Constable these effects
are clearly recognized, and in his lectures he

enunciates the essential idea of Impressionism quite clearly by saying that everything is reflected, more or less, in everything else—that the sky is not reflected in the water only, but also in the grass and in the stones, and again the grass is reflected in the tree-trunk, and so forth. It is, of course, quite true that he never pushed his observation of this to the lengths that Monet and Pissaro and Sisley did fifty years later; he never discovered that new range of colour chords which came from studying effects of strong sunlight out of doors: but that was partly because his personal taste and feeling were towards more subdued effects, under stormy skies or dull evenings. But within that range he has never been surpassed or even equalled. Nearly every one of his small studies is a discovery—a discovery of some moment when the tones and colours reveal themselves as suddenly brought together in a new and altogether unexpected harmony. And Constable is content to leave it at that; he is infinitely discreet and self-effacing—he is never there to jog our elbow and say, Don't you see how stunning that is? Still less does he ever hint what a great man he is to have found it. He leaves us alone with his impression to make what we can of it, to repeat, in contemplating his picture, the experience he had before nature and to feel gradually the mood which emanates from it—a mood which is all the rarer and more moving in

being far too subtle and too complicated to be defined in any way. For Constable refrains from doing anything to make it more explicit or more effective; he knows that to touch it in any way is to limit and distort it.

He often reminds us of Corot in the subtlety and delicacy of his nature, but in this respect he is even more discreet, more self-effacing, than Corot. For even in those early works, where we see the real man, Corot will now and again make a harmony a little sweeter and more obvious than his vision seems to have dictated.

In this perfect sincerity and artistic good breeding Constable is comparable to Velazquez. And as in the case of Velazquez his reward is that although he may hang unnoticed on the wall for a long time, and see the crowds running towards the more strident appeals of poetical landscape, he never loses an admirer whom he has once attracted.

Thanks to the late Mr. Salting's exquisite taste, we have in the National Gallery Constable's picture of *Malvern Hall*, which, perhaps, more than any other, gives the quintessence of his art. Of course no black and white reproduction can do justice to Constable, because he is so essentially a great colourist, and here the colour scheme reveals his extraordinarily delicate sensibility. It is a very ordinary scene of English park land seen towards evening with a clear rain-washed

sky. There was nothing here to arrest the lover of picturesque or striking scenery; it could only be significant to one who could see the relations between the dull greens of trees and grass and the pinkish house and pearly sky, just as Constable saw it. One cannot say that he has altered anything; we recognize everything as an almost exact statement of the visible facts of the situation; only we know that the same facts stated by another artist might have almost no meaning; that the slightest change in any one tone or colour would upset the delicate balance upon which the whole thing depends. Even Corot, as I think, would have made that harmony just a little easier and pleasanter; he would not have accepted quite so frankly the extraordinary difficulties which the greens of nature in such a situation present. Perhaps one must be something of a painter to know how nearly miraculous this is, but one need not be a painter to feel the enchantment of the mood it elicits—the extraordinary stillness, loneliness and tranquillity—nor is it a fixed and static tranquillity such as Poussin might have given—it is so fragile that we feel how soon it must pass, and our feeling of its beauty is heightened by its evanescence.

Here, then, in Constable we get the true type of the contemplative artist, the exact opposite of Turner, the active maker of pictures. And you see

that Constable's attitude is much more like that of the man of science than of the craftsman. The man of science is fired by his passion for the adventure of discovering new causal harmonies in nature. The contemplative artist is also an adventurer, a discoverer of the mysterious significance of his own experiences in front of nature.

Constable is the most striking instance in British art of that adventurous spirit. That it should be, on the whole, so rare, is a strangely paradoxical fact, in view of the grand adventures of men like Darwin and Clerk Maxwell. However, Constable remains a magnificent example, for he carried on his adventure under the most unfavourable circumstances. He was completely alone. There seems to have been no one who understood at all what he was up to. It was only once, when he exhibited in Paris in 1824, that French painters recognized the greatness of his revelation. And Constable's violent Gallophobia prevented his getting much satisfaction from this tribute. In England he was only grudgingly admitted, after embittering delays, to the Royal Academy, and indeed, never had any but a modest success. Not that this would have mattered. Even so, he was far better off financially than the French Impressionists, only, whereas they formed a band of enthusiastic friends who watched and criticized and acclaimed each new discovery as it was made, Constable had

no real critic, no one who could follow and appreciate his endeavours.

And he was, one gathers, a humble man who listened to others and would have welcomed intelligent criticism. He was more understood, perhaps, by members of the public, men like Archdeacon Fisher, than by the professional critics, who were rarely favourable, or by artists.

That, indeed, is what one cannot understand. How came it that the younger artists did not rally round him, realizing what new vistas he was opening for them to explore? But it was the hey-day of romanticism—men wanted the strongly spiced fare that Turner was providing; Constable, the daring innovator, seemed a dull fellow without imagination. That, indeed, he was, if one means by imagination, as is so often done, the power to conceive *a priori* inventions, but imagination, in the sense of the power to probe and grasp the significance of the complex of appearances, imagination of the kind that we find in Velazquez and de Hooch, and Courbet and Degas, that he had, as none of his contemporaries.

The wonder, then, is that he pursued his solitary adventure with such patient tenacity, and so far, not that towards the end he lost impetus and rather relapsed to less daring efforts. And always the influence of his ambience impelled him to spend most of his time in London elaborating those

great machines which were calculated to produce an effect in the Academy exhibitions. The habit of making these was entirely bad. They are almost always compromises with his real idea. He watered that down, filling it out with redundant statements of detail which merely satisfy an idle curiosity and inevitably obscures the essential theme.

How much better if he had had the courage and the means to stay in his native country and give himself entirely to intensifying and deepening his new vision of nature! Fortunately, however, he frequently did full-size studies for these pictures, and it is to those and to the sketches that we must turn to find the real Constable.[1]

Like Turner, Constable was an intense admirer and a deep student of Claude, but he went to Claude not in order to borrow his ideas, but to help him to probe deeper into his own vision, to enrich and intensify that. He went also to the early

[1] This was admirably seen at Burlington House, where were both the full-size study for the *Leaping Horse* (V. & A.) and the finished picture. In the study there is a beautiful balance between the tree masses to the left and a piled-up incumbent mass of cloud to the right, while the leaping horse is balanced by the willow tree to the right. Neither of these survive in the final version, where everything is concentrated on the vista to the right—there is no longer the same interplay of answering motives, to the great enfeeblement of the design. Nor is this all. Everywhere the addition of greater detail has weakened the substance and solidity of the structure.

Gainsborough landscapes and to the Dutch, but nowhere does he show direct evidence of all this study. It was not till he had completely assimilated what he learned and incorporated it in his own vision that it became operative. So Constable is from the first entirely himself, and he remains so to the end. All his developments are logical unfoldings of his reaction to nature.

In an early work like the *Dedham* (*Fig. 62*) Constable has not moved very far from the position of Gainsborough's early landscapes, only there is a greater willingness to accept the actual tones and colours of nature, to wait on them without any preconception of what a picture ought to be like. So there is already a new note of freshness, a new air circulating in the sky, and a new luminosity filling the valley. And at once we see how sensitive he is to design by the perfect choice of the quantities and of the intervals, by his choice of the exact spot for the accent made by the cows. And yet it is so simple, so unobtrusive, that we can imagine people never suspecting the art that underlies this. Constable understood the principle of concealing his art.

We must turn to Constable's small studies of landscape to find what is most original in his art. I cannot doubt that they were painted direct from nature, so intimately do they render those elusive and incalculable qualities which distinguish any

particular moment and situation from all others. Take, for instance, the sketch on the slopes of the Stour Valley (*Fig. 63*). However familiar one may be with the diversities of nature, one could never have foretold the peculiar shade of warm yellowish grey which the meadows have taken here. It is late on an October afternoon, and the tempered sunlight falling on the grass, bleached by summer heats, gives this strange and unexpected note, and Constable has made of it the basis for a harmony of the rarest kind. These warm greys melt by gradations as we follow them across the valley into the impalpable blueness of the distance. The woods in the middle distance have lost their greens and taken on a yellowish grey note, a deeper and stronger version of the pale fields, and here and there they flush faintly to a chestnut brown, but all these colours are veiled by the film of luminous air which intervenes. Above, the lower sky is piled with cumulus, so veiled in bluish vapour that we can barely see where they pass into the paler blue of the upper air. So rare and so unimaginable a harmony, so rich in internal echoes and reflections, could only have been grasped by one whose contemplative spirit had always been at once patient and alert.

As I say, nearly every such study is a new discovery. No one has seen as he did just the unique pinkish greyness of the slopes of the South

Downs or the indefinable golden brown of sunlit London brick seen against a leaden sky. This is not, of course, a question of mere accuracy of observation; the whole point of Constable's method, as with all the other great naturalistic painters, is that by this method they achieve richer, more complex, and more intimately co-ordinated harmonies than are possible even to the most fertile of purely inventive colourists.

It is characteristic of Constable's sketches that all the elements of the design and the essential colour scheme are put down with almost reckless abandon. Constable, I think, never bothered about what his pictures were going to look like— he had no preoccupation with technical beauties of quality as such. All he cared for was the fullest possible realization of the idea which had fired his imagination; all he asked of his pigment was to become the best vehicle of that. And the consequence is that his pictures still have all their freshness and transparency.

No doubt in his bigger pictures, and especially in such full-size studies as those for the *Leaping Horse* and the *Hay Wain*, Constable had recourse to more complicated methods, using a rich impasto laid in sometimes with a palette knife and modified by subsequent glazes of transparent colour. He was, indeed, fertile in all manner of technical inventions which might help him to attain the

PLATE XXXIX

65. JOHN CONSTABLE : *Bergholt*
Sir Michael Sadler Collection

PLATE XL

66. JOHN CONSTABLE : *Hampstead Heath*
Sir Michael Sadler Collection

fullest realization of his idea, but it was always that at which he aimed, never the elaboration of a beautiful quality for its own sake. And the same attitude gives a special value to his watercolours, for he uses the medium with complete freedom, unchecked by those technical scruples which so hampered the more professional watercolourists. He uses it, in short, as Claude and Poussin had done, and sometimes his monochrome wash drawings are curiously like theirs, only they show perhaps a keener sense of the play of shifting light and shadow.

The sketch of *Stoke-by-Nayland* (*Fig. 59*) shows with what astonishing economy he could state the essentials of a momentary effect of shifting light and shade. *The Mill* (*Fig. 34*) is an example of a fuller treatment. It would be difficult to surpass this in the use of water-colour, so complete is the expression of the whole spatial disposition of the masses, so broad the use of light and shade, and what life and movement is given by the exact placing of all the minute accents which underline the form at critical moments!

But to return to Constable's oil-paintings—we may take the full-size study for the *Leaping Horse*, at the Victoria and Albert, as marking perhaps the highest flight of Constable's imagination. In some ways it goes beyond anything that has been done since. In it Constable expressed those fluctuating

interchanges and interactions between all the objects of a scene by which every part becomes linked with the whole. The shifting lights of diverse colours which strike from all directions so invade and penetrate the different parts of each object in diverse ways that they become interwoven into the pictorial weft, they lose in part their separate identity and become, as it were, nodes in this continuum. It is the full realization of this that gives such incredible life and movement to the design. And yet Constable has managed to keep the essentials of its architecture; everything has its due volume and mass although nothing can be distinctly isolated from the whole.

Another almost equally astonishing work is the little study for the *Opening of Waterloo Bridge*, at the Victoria and Albert Museum, where the glitter of shifting lights on the crowded shores and boats of the foreground flickers away into the distant horizon with endless fluctuations and variations. It is an astounding effort of the imaginative grasp of an infinitely complex and elusive appearance.

It is difficult to believe that such work was done more than a hundred years ago. Like all the great discoverers of appearance, like Velazquez and de Hooch and Chardin, Constable refuses to 'date'.

So little, indeed, did he 'date' that he gives no suggestion of his period. That curious disease of taste and sentiment, the ravages of which we have

noted, even in men of great talent like Lawrence and Bonington and Turner, seems never to have touched Constable at all. That tendency to meagre and slippery elegance, with thin, sharp accents and false colour, which affected all our art finds no echo in his work. All through his *œuvre* the tonal texture remains firm, consistent and dense, and his colour never loses its rich sobriety and coherence.

Even his rare figure paintings, of which *Fig. 64* gives an example, show no sign of the false sentiment of the time. It indicates a broad and simple understanding of the essential form, with a vigorous grasp of the volume, relief and movement of the figure. There is here no flimsy idealism or sentimental distortion. It is as honest and straightforward as a Rubens. Constable, like Gainsborough, belongs to the great European tradition of plastic design.

How strange it seems when we consider how vast a future development Constable's work had suggested—how strange that, when the young Pre-Raphaelites were trying to escape from the horrors of Victorian picture-making, some sketch of Constable's did not whisper that here was the way to a genuine and unexplored art. But here, as so often in our history, the rooted notion that the specific nature of pictorial design is not sufficiently imposing, that the feelings it alone can communicate

CONSTABLE

are not sufficiently elevated and valuable to occupy the artist's utmost endeavours—that, in short, they must be poets at all costs—was the cause of their failure. With a little more clear thinking, a little more honesty and less pretension to a high calling, what an art we might have had!